IMAGES
of America

ST. MARY'S
COUNTY

IMAGES
of America

ST. MARY'S COUNTY

Linda Davis Reno

Linda Davis Reno
10/20/2004

ARCADIA

Copyright © 2004 by Linda Davis Reno
ISBN 0-7385-1661-9

Published by Arcadia Publishing
Charleston SC, Chicago IL, Portsmouth NH, San Francisco CA

Printed in Great Britain

Library of Congress Catalog Card Number: 2004103641

For all general information contact Arcadia Publishing at:
Telephone 843-853-2070
Fax 843-853-0044
E-mail sales@arcadiapublishing.com
For customer service and orders:
Toll-Free 1-888-313-2665

Visit us on the internet at http://www.arcadiapublishing.com

Contents

Acknowledgments		6
Introduction		7
1.	The Colony	9
2.	Hearth and Home	15
3.	Towns and Commerce	35
4.	Churches and Schools	49
5.	By Land, Sea, and Sky	67
6.	Families	81
7.	War and Peace	103
8.	Law and Order	111
8.	Food, Fun, and Potent Potables	119

ACKNOWLEDGMENTS

The quest for the photographs used in this book was undoubtedly the best part of this experience. Every person and organization contacted shared their collections very freely and willingly without question and afforded me the opportunity to see this beautiful place through their eyes and memories.

Juanita Gass, Alice McWilliams, Francis and Beverly Gibson, Louis Buckler, Faye Johnson, and Doug Lister provided educational, insightful, and fun tours. Joyce Bennett and Pete Wigginton were both extremely supportive and helpful in the selection and providing of pictures. They also shared their vast knowledge of our history and many interesting stories along the way. Joann Ellis Humphries was, as always, available to lend a helping hand in any part of this project.

A huge debt of gratitude is owed to the following organizations and individuals for providing access to their photographs: Carol Moody and Polly Barbour, St. Mary's County Historical Society; Kathryn Ryner, St. Mary's College of Maryland; Silas Hurry, Historic St. Mary's City Commission; Lydia Wood and Christina Clagget, St. Clement's Island Museum; Judge Karen Abrams; Evelyn Arnold, clerk of the Circuit Court; John Richards, St. Mary's County Fair Board; Ralph Eshelman; Dr. J. Roy Guyther; Patty and Bill Poffenbarger; Jim and Marie Chesley; Betty Peterson; Scott Lawrence; Ashley Hill; Juanita Gass; Randy Dunavan; Purnell and Rita Frederick; Doug Lister; Judy Dean Wood; Dave Cummins; Lois Duke; Thomas B. Darlington; Susan McMillan, Charlotte Hall Veteran's Home; David Roberts; Kenny and Kathy Robeson; Fr. Damian Shadwell, St. Peter Claver Church; Bill Johnson; Charles Gray; Joshua Humphries; Don Mueller; Maryland State Archives; Heather Ostrom; Carroll Patterson; Mary Ellen Hamilton, Oscar Getz Museum of Whiskey History; Pat Perez, Maritime Industry Museum, Maritime College, SUNY; John Ford; Phyllis Superior; Rob Long; Dave Mark; J. Harry Norris; Sandy Geisbert Ondrejcak; and Dick Gass.

A very special thank you is extended to Mr. David Cummins for pictures and drawings. Without his support, this project would not have been possible.

REFERENCES

Beitzell, Edwin. *The Jesuit Missions of St. Mary's County, Maryland.* Abell, MD: 1976.
Fresco, Margaret King. *Doctors of St. Mary's County.* Ridge, MD: 1992.
Guyther, J. Roy, M.D. *Charlotte Hall, The Village, 1797–1997.* Mechanicsville, MD: 1997.
Guyther, J. Roy, M.D. *Mechanicsville, The Story of Our Village.* Mechanicsville, MD: 1994.
Hammett, Regina Combs. *History of St. Mary's County, Maryland.* Ridge, MD: 1977.
Maryland Historical Trust. *Inventory of Historic Sites in Calvert County, Charles County and St. Mary's Co.* Annapolis, MD: 1980.
St. Mary's County Historical Society. *Chronicles of St. Mary's.* Leonardtown, MD.
Walsh, Rev. Francis. *A Pictorial History of Saint Inigoes Mission, 1634–1984.* St. Inigoes, MD: 1984.

INTRODUCTION

In 1632 George Calvert, the first Lord Baltimore, was posthumously granted a part of Virginia north and east of the Potomac River, between 38 degrees and 40 degrees north latitude, by King Charles I. The designated area included all of what is now Maryland, Delaware, and the southern part of Pennsylvania up to about present-day Philadelphia.

Cecil Calvert, eldest son and heir of George Calvert, became the second Lord Baltimore. He designated his younger brother Leonard as governor of the colony and sent with him 20 gentlemen, 300 laborers, and 2 Catholic fathers, Andrew White and John Altham, to begin the Maryland colonization.

In England land was in short supply, but the new colony of Maryland contained about seven million acres. The *Conditions of Plantation* was the framework for granting land. For every five able man between the ages of 16 and 50 that a man could bring with him, 1,000 acres would be granted. Those transporting themselves and less than five able men aged 16 to 50 received 100 acres for themselves and 100 acres per servant. A married man received 100 acres for himself, 100 acres for his wife, and 50 acres for each child under the age of 16; a woman with children received 100 acres for herself and 50 acres for each child under the age of 6; and any woman transporting female servants under the age of 40 received 50 acres for each servant.

Indentured servants made up the majority of the population in early Maryland. In return for payment for their voyage, people would agree to serve between five and seven years. During their term of indenture, they could expect to work 6 days each week, 10 to 14 hours per day. Upon completion of their service, they would receive a good cloth suit of jersey or broadcloth, a shift of white linen, a pair of stockings and shoes, 2 hoes, an axe, 3 barrels of corn, and 50 acres of land (at least 5 of which had to be fertile).

Although very few in number, there were African-American immigrants. One of these was Matthias de Sousa, who as a landowner, not only voted but also served as a member of Maryland's General Assembly. Several hundred years later he would be portrayed by Denzel Washington while Washington was a student in a play at Fordham University.

There were also slaves here as early as 1658, but they would not be the only immigrants to arrive in bondage. After the Siege of Preston in 1715 and the Jacobite rebellion in 1745, Scotland shipped thousands of prisoners to Maryland and Virginia for sale as indentured servants. Some of these servants were sold from the wharf at Chaptico. The difference, of course, was that the Jacobite prisoners would be freed after a stipulated time of service while the slaves would not.

Although it was established as a Catholic colony, anyone, regardless of religious affiliation, was welcome. There were people from all religious backgrounds who came to Maryland—Catholics, Protestants, Quakers, and Jews. The Act of Religion (actually a reaffirmation of Lord Baltimore's directions to settlers at the time Maryland was to be settled) passed by the Maryland legislature on June 21, 1649, established two of a number of major firsts in America: freedom of religion and separation of church and state. Through Mistress Margaret Brent, who immigrated

in 1638, St. Mary's County would also be the site for America's first woman lawyer, first woman landowner, first woman taxpayer, and first American woman to ask for the privilege of voting.

From the beginning, the young colony had its share of problems. Although the charter for Maryland encompassed Kent Island, William Claiborne of Virginia claimed it as his own. Eventually there was open warfare that would last, off and on, from early 1635 to 1638, when Claiborne's adherents were captured and one of the leaders, Thomas Smyth, was hanged as a pirate. Claiborne was permanently banished from Maryland and all of his property was seized; nevertheless, he would continue to press his claims of ownership of Kent Island and cause problems for Maryland until his own death in 1677.

In 1645 Richard Ingle invaded and occupied St. Mary's for a period of two years that became known as the "plundering time." Governor Calvert and about 300 of the estimated 400 colonists fled to Virginia. The property of "papists and malignants" was seized. Frs. Andrew White and Thomas Copley were put in chains and sent to England. In late 1646 Governor Calvert, accompanied by the displaced Marylanders and soldiers recruited in Virginia, regained control of Maryland. In 1648, after the death of Leonard Calvert, William Stone was named as the first Protestant governor of Maryland. Governor Stone invited the Puritans, then living in Virginia, to take sanctuary in Maryland, and about 300 settled along the Severn River. In 1652 the Puritans and William Claiborne joined forces, forcing Governor Stone to resign. The Puritans took control of Maryland. Catholics were disenfranchised, and the Toleration Act of 1649 was repealed.

On March 25, 1655, in what would be the first naval battle on American soil, Governor Stone and a force of 130 Marylanders unsuccessfully attempted to regain control of the colony. Three Marylanders, despite the promised "quarter" in return for surrender, were hanged. Maryland was restored to Lord Baltimore in 1656 when he appealed to Oliver Cromwell. The Act of Religious Toleration was immediately put back into effect.

In July 1656 Lord Baltimore appointed Josias Fendall as governor. In 1660 Fendall sought to overturn the government. This bloodless coup, now called "Fendall's Rebellion," was short lived. Fendall, along with Thomas Gerard and John Hatch, who had aligned themselves with him, were tried in Provincial Court. Originally they were sentenced to banishment and forfeiture of estates, but this was reduced to perpetual disenfranchisement. In 1681 Fendall attempted another revolt and again failed. This time he was banished from Maryland and died in Virginia in 1688.

In 1689 the Protestant Revolution would forever alter the history of Maryland. It started in St. Mary's County with John Coode (Coad), Kenelm Cheseldine, Henry Jowles, and Nehemiah Blackistone, all staunch Protestants who felt that they were the victims of political and religious favoritism. Protestants took control on August 1, 1689. Catholics were no longer allowed to hold office, serve on juries, or to bear arms. Religious toleration was now something of the past, and in 1692 the Anglican Church was named as the official church of Maryland. All colonists, regardless of religious affiliation, were taxed for its support. All Catholic churches and schools in the province were closed, and Catholics would not openly worship again until after the Revolutionary War.

In 1695 the Puritans, who had been attempting to have the capital moved to Anne Arundel Town (now known as Annapolis) since 1674, found a friend in Gov. Francis Nicholson, the second royal governor. Despite a petition from the inhabitants of St. Mary's County, the move was made.

Some would make the mistake of assuming that with this move St. Mary's County was nothing more than a backwater place of little importance, but they would be proven wrong time and time again. St. Mary's County and her citizens have played a major role in every important event affecting the America we know today.

One
THE COLONY

Plans were carefully crafted to ensure the success of the Maryland colony. Skilled workers like coopers and carpenters were recruited, but others willing to work hard were also a vital part of the equation.

To avoid conflict among the colonists, Catholics were admonished to be "silent upon all occasions of discourse concerning matters of religion, at land as well as sea." Instructions were provided in how to deal with the Native Americans, anticipated sabotage from Virginia, and other issues. Shortly after the departure of the Ark and Dove, Lord Baltimore wrote to a friend, "I have sent a hopeful Colony to Maryland, with a fair and probable expectation of good success."

Fr. Andrew White, who chronicled the first voyage, immediately sent the following report to Lord Baltimore. It was published in the summer of 1634 as A Relation of Maryland and used to recruit colonists for a second voyage:

> Whosoever intends to partake in this second Voyage, must come, or send before the 20th of October next ensuing, to M. William Peaseley Esq. his Lordsh. brother-in-law, at his house on the back-side of Drury-lane, over against the Cock-pit on the field-side: And there to him deliver their transportation money, according to the number of men they meane to send over, at the rate of six pounds a man, to the end convenient passage may bee reserved for them, in his Lordsh. shipping; beyond which time it will not be profitable for any to partake in this second Voyage.

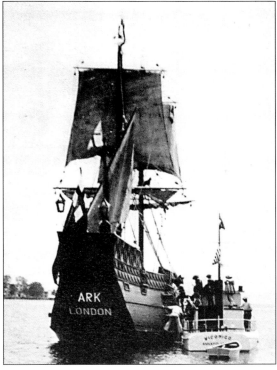

THE ARK. On November 22, 1633, two small ships departed from Cowes, Isle of Wight, England, on their journey to the New World. The larger of these ships was the *Ark*. She was capable of greater speed but slowed her travel so as not to leave the *Dove* behind. However, four days into their journey the ships encountered a violent storm and were separated. The *Dove* was presumed to have been lost. (Courtesy St. Mary's County Historical Society.)

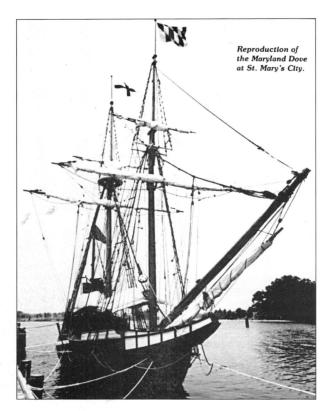

Reproduction of the Maryland Dove at St. Mary's City.

THE DOVE. On January 3, 1634, the *Ark* arrived in Barbados and remained there for three weeks. To the joy of the colonists, shortly after their arrival, the *Dove* sailed into port, having returned to England to wait out the first storm. The reunited ships visited a number of other islands in the Caribbean, arriving off Point Comfort, Virginia, on February 27. Shortly thereafter the colonists set sail up the Chesapeake Bay to their final destination. (Courtesy St. Mary's County Historical Society.)

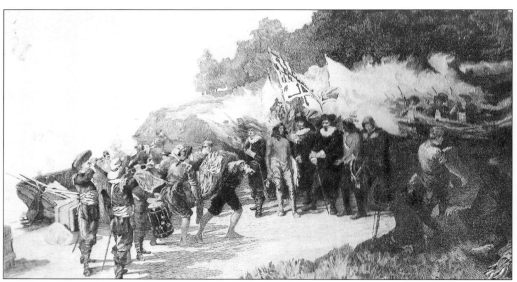

THE LANDING. Shortly after the colonists arrived, Gov. Leonard Calvert, accompanied by Henry Fleet serving as interpreter, sailed further up the Potomac to meet the emperor of the Piscataway Indians who "gave leave to us to sett down where we pleased." On March 25, 1634, Fr. Andrew White celebrated Mass and a wooden cross was erected to mark the official beginning of Maryland.

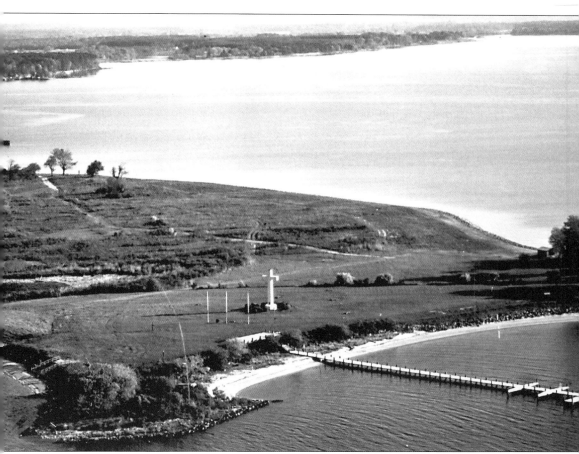

ST. CLEMENT'S ISLAND. This aerial view of St. Clement's Island, the site of Maryland's founding, shows it in more modern times. Time and tide have taken a toll. Only about 40 acres remain of the approximately 400 acres it contained in 1634. St. Clement's Island was a part of the tract called St. Clement's Manor granted to Thomas Gerard in 1639. On May 6, 1669, Col. Nehemiah Blackistone married Elizabeth, daughter of Thomas Gerard, and by this marriage obtained St. Clement's Island, often referred to after that as Blackistone's Island. Nehemiah Blackistone was a descendant of King Edward III and the son of John Blackistone, M.P., one of the judges who pronounced the sentence of death on King Charles I in 1649. Nehemiah was a planter, attorney, a judge of the Provincial Court, and a colonel in the militia. He was also one of the leaders of the Protestant Revolution in 1689. Colonel Blackistone died in 1693, survived by his widow, Elizabeth (Gerard), who subsequently married twice more. She died in 1716. The lighthouse shown here burned, but plans are underway to rebuild. (Courtesy Dick Gass.)

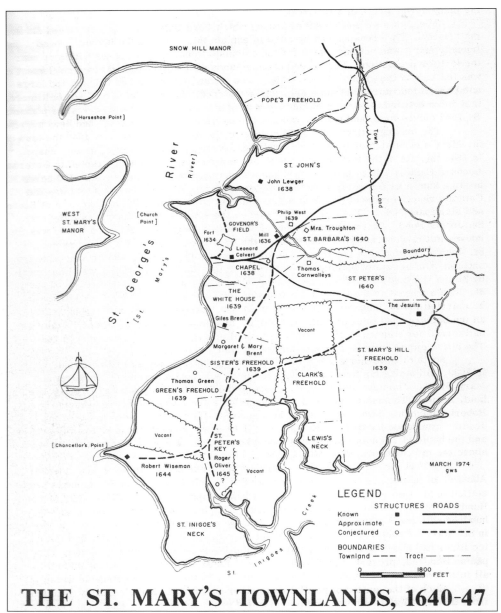

THE ST. MARY'S TOWNLANDS, 1640-47

ST. MARY'S CITY TOWNLANDS. Governor Calvert bought approximately the whole of what is now St. Mary's County from the Yaocomico Indians for tools and cloth on the site that is now St. Mary's City. Chosen for its accessibility and also because it afforded a strategic location for defense of the colonists, this became the site of the first permanent settlement in Maryland. In 1636 Cecilius Calvert directed his brother, Gov. Leonard Calvert, to allot 10 acres of town property to each of the first adventurers and 5 acres for each person the adventurer had transported or brought into Maryland. Many of the colonists declined town land, preferring to settle on larger tracts to which they were entitled by the *Conditions of Plantation*. Of the approximately 400 people living in Maryland in 1641, only 90 were living in or around St. Mary's City. (Courtesy Historic St. Mary's City Commission.)

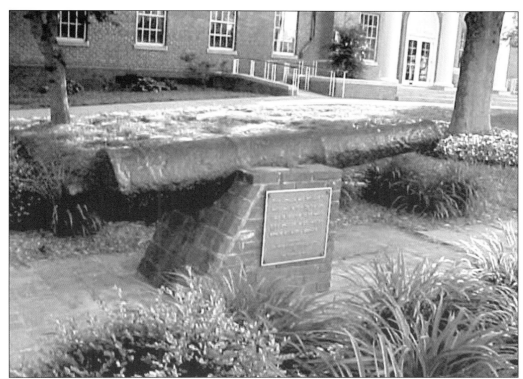

CANNONS. In 1634, when Fr. Andrew White chronicled the landing of the Maryland colonists, he wrote that the cannons fired from aboard ship filled the Yaocomoco Indians "with wonder." The cannon in this picture was undoubtedly one of those to which Father White referred as it was brought to Maryland on the *Ark*. For many years, it served as a boundary marker at St. Inigoes Manor but now stands on the courthouse lawn.

FREEDOM OF CONSCIENCE. Cecilius Calvert, a Catholic, admonished the leaders of the first Maryland voyage to "suffer no scandall nor offence to be given to any of the Protestants" among the passengers; in 1649 the Act of Religious Toleration was enacted at St. Mary's City. The Freedom of Conscience statue, shown here, was erected in 1934 to commemorate these two historic firsts in America: freedom of religion and separation of church and state.

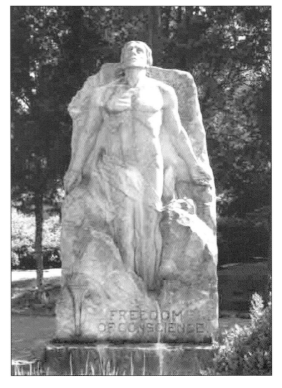

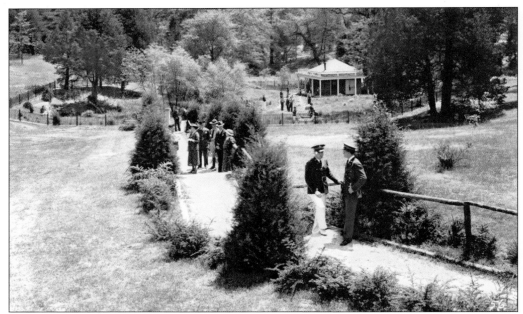

YE COOLE SPRINGS. The site of the first hospital in Maryland and one of the earliest in the colonies, the springs at Charlotte Hall in 1697 were reputed to "have a very medicinal and healing quality in it and proves very effectual to curing all sorts of distempers and diseases of body and the abundance of impotent, lame and diseased people do dayly flock thither for cure and receive great benefitt thereby." (Courtesy J. Roy Guyther, M.D.)

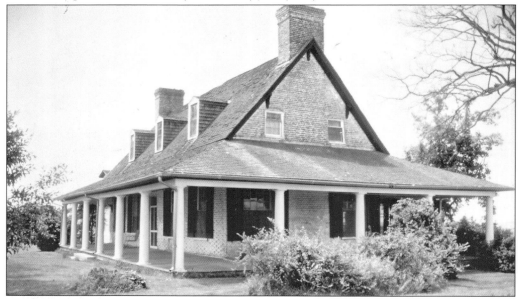

OCEAN HALL. Said to be the oldest home still standing in St. Mary's County, this house appears to have been built prior to the will of Robert Slye, dated January 18, 1670. In his will he devised to his wife Susanna the house and part of the land at "Bushwood," a 1,000-acre tract he received upon his marriage to her, the eldest daughter of Thomas Gerard. (Courtesy St. Mary's County Historical Society.)

Two
Hearth and Home

The colonists selected the site of what is now St. Mary's City for two major reasons: its strategic location and the existing Yaocomico Indian village at that site. Several fields were already cleared and available immediately for planting. The colonists probably lived in the Native American huts until they could erect homes. The first order of business would have been to get crops in the ground to ensure adequate food supplies for the next winter. Building a house during that time was no small task. The first homes, generally only one room, were rudimentary, providing only basic shelter. In 1638 it was reported that all of the colonists still lived in cottages made of "wattle and daub" with thatched roofs. When homes were eventually built, they were typically of frame construction, including the chimneys. It was only the gentry who could afford to build larger homes, and sometimes even their homes served a dual purpose. Both the homes of Gov. Leonard Calvert and Sec. John Lewger were used as the meeting place for the assembly, council, and sessions of the Prerogative Court. While by no means complete, this chapter includes some of the representative homes of St. Mary's County. Sadly, many of them no longer stand.

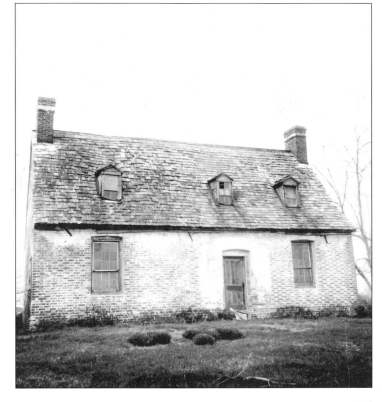

Resurrection Manor. Resurrection Manor, which included 4,000 acres, was patented by Thomas Cornwallis on March 24, 1650. After Cornwallis returned to England in 1659, the property changed hands several times, but it was in the ownership of George Plowden by 1707. The actual date that the house was built is not known, although some say the late 1600s or about 1730. The house was demolished in late 2002. (Courtesy St. Mary's County Historical Society.)

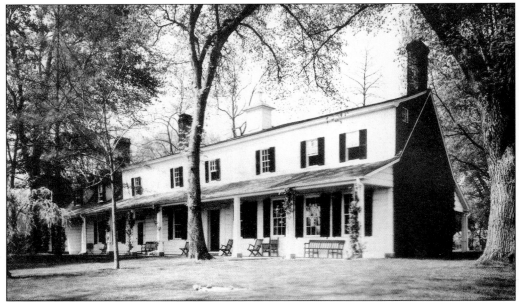

SOTTERLEY. James Bowles, son of Tobias Bowles, a wealthy merchant in England, came to Maryland in 1699 to serve as his father's business representative. He began acquiring properties, one of which he named "Bowles' Preservation." About 1717 he began building a small house on that site. In later years the house was enlarged and remodeled. The house, which is open to the public, is carefully maintained by the Sotterley Foundation, Inc. (Courtesy St. Mary's County Historical Society.)

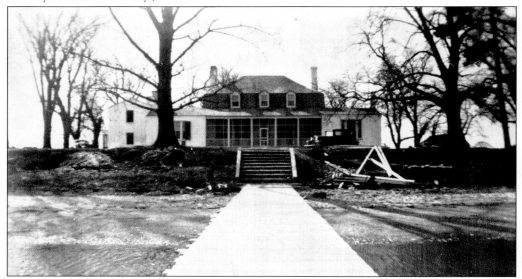

THE PLAINS. This plantation, home of the Sothoron family for generations, was confiscated by federal authorities in 1864 after Col. John Sothoron killed a Union officer who attempted to recruit his slaves. Colonel Sothoron fled to Virginia. He returned in 1866, was tried, and was found innocent of manslaughter by a St. Mary's County court. The house no longer stands, but the family and slave cemeteries are carefully preserved by the residents of Golden Beach. (Courtesy Polly and Bill Poffenbarger.)

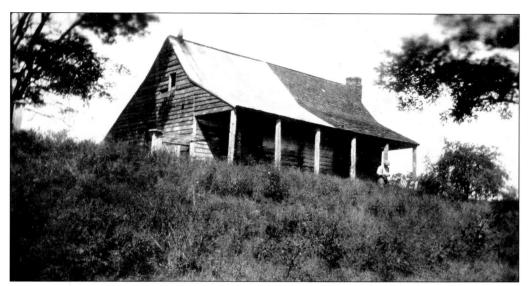

SLAVE CABIN AT THE PLAINS. This picture, one of only a very few that exist, shows one of undoubtedly several houses occupied by slaves at The Plains. Generally built by the slaves themselves, they usually contained only one room, dirt floors, and a fireplace for heat and cooking. Sleeping quarters were usually a loft overhead, accessed by a ladder. (Courtesy Historic St. Mary's City Commission.)

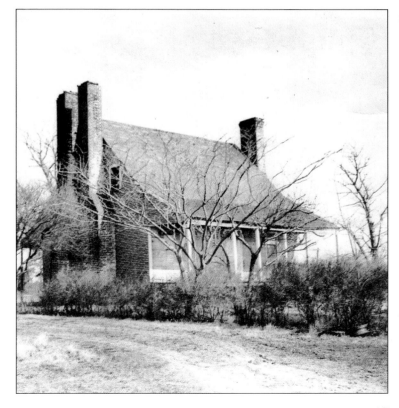

BARD'S FIELD. Thomas Loker (1751–1804) is credited for building this house about 1800. It is located at Trinity Manor near Ridge. His wife, Rebecca Mackall, a native of Calvert County, was the aunt of Margaret Mackall Smith, wife of President Zachary Taylor. Rebecca and several of her children are buried in a small cemetery near the house. Currently used as a bed and breakfast, the house has been beautifully restored. (Courtesy St. Mary's County Historical Society.)

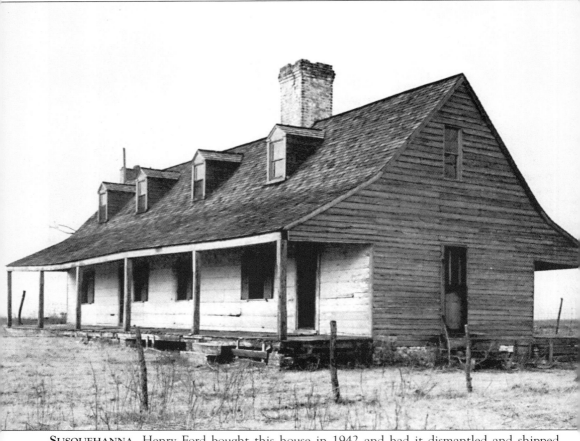

Susquehanna. Henry Ford bought this house in 1942 and had it dismantled and shipped to Greenfield Village, his museum in Dearborn, Michigan. Lying nearby was the tombstone of Christopher and John Rousby, which he also took, leaving behind their mortal remains. The tombstone reads, "Here lyeth the Body of Xpher Rousbie Esquire Who was taken out of this world by a violent death received on Board his Majesty's Ship the Quaker Ketch, Cap' Thos. Allen commander the last day of Oct'r 1684. And alsoe of Mr. John Rousbie, his Brother, who departed this Natural Life on Board the Ship Baltimore. Being arrived in Patuxon River the first day of February 1685 'memento mori'." The tombstone, now in pieces, was recently returned and is at the Jefferson Patterson Park and Museum in Calvert County for repair and restoration. Although it will never be used to mark the original burial site, it will eventually be returned to St. Mary's County and placed on display. Originally it was believed this house was built much earlier, but more extensive research indicates that it was actually built about 1760. Susquehanna remains on display at Greenfield Village. (Courtesy St. Mary's County Historical Society.)

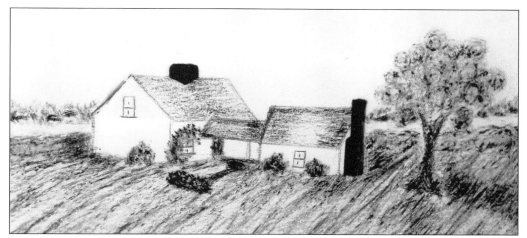

QUEEN TREE. Also known as "Dixon's Purchase," this very old home once stood on part of Delabrooke Manor near Oakville. This crayon drawing was made in 1956, from memory, by Mary Dixon, daughter of Daniel T. Dixon and Sarah (Payne) Floyd. Mary died in 1993 just two months short of her 105th birthday. Her family lived in this house for many years before moving to Laurel Grove. (Courtesy St. Mary's County Historical Society.)

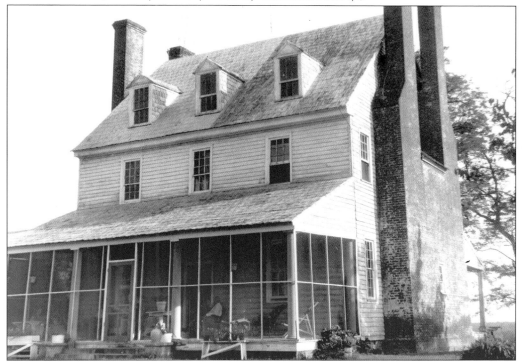

SAVONA. Built in the early 19th century, this home is located north of Chaptico overlooking Chaptico Bay, the Wicomico River, and the Potomac River. Catherine Hayden, known as the "Angel of Chaptico," was born here in 1840. At great personal risk, she provided food and medicine to Confederate soldiers as they tried to escape into Virginia. When she died in 1872, her family received many letters of condolence from these Southern veterans. (Courtesy St. Mary's County Historical Society.)

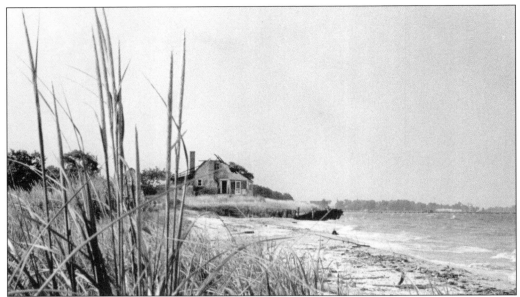

LONG LANE FARM. This house, facing the Chesapeake Bay, may have been built by James Jarboe shortly after 1765 when he acquired the property from Abraham Barnes and his second wife, Elizabeth Rousby. In 1774 the property was in the possession of his son, Robert Jarboe. In 1803 Robert Jarboe left it to his son, Col. James Jarboe. The house was torn down in 1972 after a major fire. (Courtesy St. Mary's County Historical Society.)

HOPEWELL-AIM. Dashiell Hammett, son of Richard Thomas Hammett and Anna R. Dashiell and author of *The Thin Man* and *The Maltese Falcon*, was born at this house, located in Great Mills, on May 27, 1894. The farm was owned by his paternal grandparents, Samuel Biscoe Hammett (1836–1910) and Ann Rebecca Hammett (1833–1894). (Courtesy St. Mary's County Historical Society.)

GRAVELLY HILLS. Built in 1847 on the site of an earlier home, Gravelly Hills has undergone careful restoration, thus preserving an important landmark in the old port town of Chaptico. On this property in 1755, Dr. John Key was poisoned by two slaves belonging to the Key family. One of the men was executed, and it was directed that his body be "hung in chains at Bird's Creek in St. Mary's County." (Courtesy St. Mary's County Historical Society.)

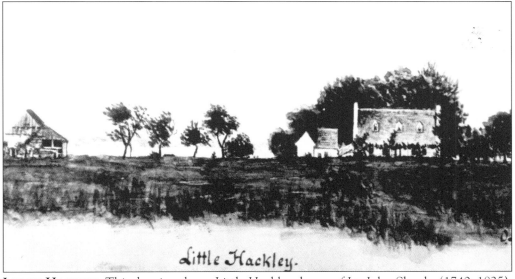

LITTLE HACKLEY. This drawing shows Little Hackley, home of Lt. John Shanks (1740–1825), a Revolutionary War soldier, and his wife, Mary Morris. Lieutenant Shanks was a descendant of John Shanks, a native of Dumfries, Scotland, who was transported to Maryland by Thomas Gerard in 1638. Today only a set of gate posts and a beautiful, tree-lined drive to the riverfront remain to remind us of this lovely old manor house. (Courtesy David Cummins.)

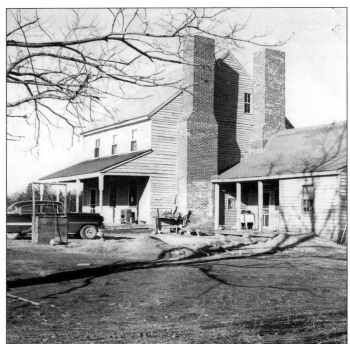

LAUREETUM. Situated near Chaptico, this was the birthplace of Revolutionary War hero and physician Dr. John Hanson Briscoe. He graduated from the University of Edinburgh (Scotland) in 1773. During the war, he was appointed surgeon of the Seven Independent Companies, and at war's end he was placed in charge of government hospitals in Philadelphia. Laureetum was originally part of a large land grant called Briscoe's Range. (Courtesy St. Mary's County Historical Society.)

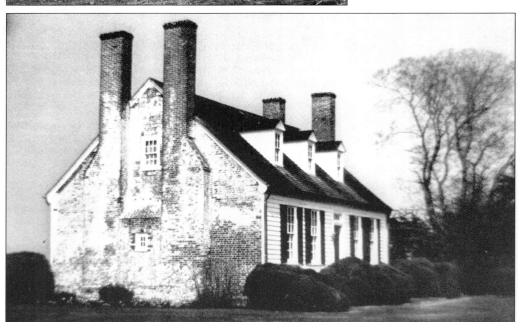

WEST ST. MARY'S MANOR. This is the name that was given to a 2,000-acre tract granted by Lord Baltimore to explorer-adventurer Henry Fleet, a Virginian who guided Leonard Calvert and the early Maryland settlers up and down the waterways of their new home. Today West St. Mary's Manor refers to the home built by William Taylor at the northern end of the original tract. The house, with its four impressive chimneys, sits high above the St. Mary's River overlooking St. Mary's City. (Courtesy St. Mary's County Historical Society.)

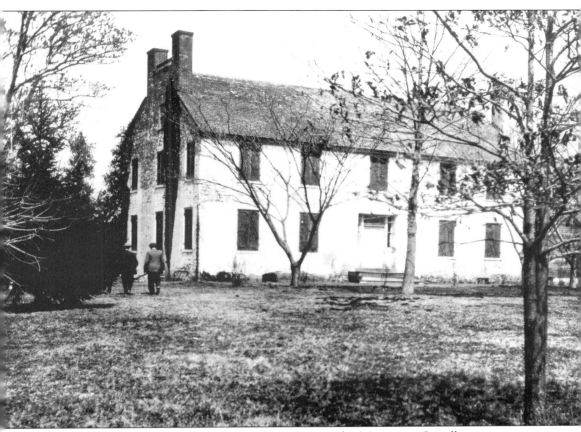

MATTAPANY-SEWALL. Originally a manor of 1,200 acres, the Mattapany-Sewall property was granted to Henry Sewall in 1663. In the mid-1830s Robert Darnall Sewall sold it to George Forbes, who in turn sold it to Richard Thomas and his wife, Jane Armstrong, in 1840. Richard Thomas died in 1849, but Jane remained at Mattapany-Sewall and raised their three sons, all of whom served as officers in the Confederacy. Richard was the best known of the three. In 1861 he was commissioned as a Confederate colonel, and shortly thereafter he boarded a Union ship in Baltimore, posing as a French woman and calling himself Madame LaForce. He and his men captured the ship and sailed her to Virginia. While en route they captured three more ships loaded with ice, coffee, and coal. Thomas died at Mattapany-Sewall in 1875. This picture was taken in 1934, prior to a number of major restorations. The oldest portion of the house was built about 1742. It now serves as the home of commander of the test facility at the Patuxent Naval Air Station. (Official United States Navy photograph.)

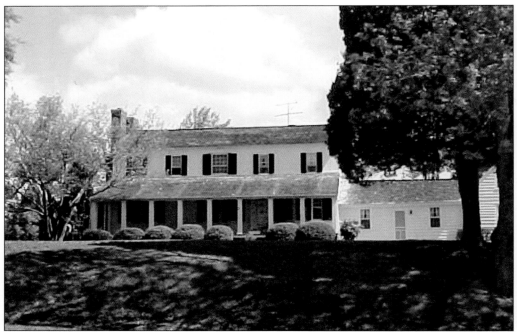

DEEP FALLS. Built in 1745 by Maj. William Thomas on property called "Wales," granted in 1680, this house is still owned by members of the Thomas family. Major Thomas and his two eldest sons, John and William, served as officers during the Revolutionary War. His third son, James, was killed at the Battle of Yorktown on April 21, 1781. The family cemetery is enclosed within a wrought-iron fence and is beautifully maintained.

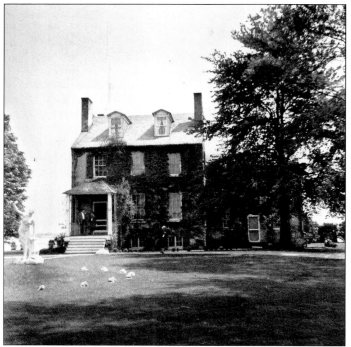

DELABROOKE. In his own hand, Robert Brooke wrote "Robert Brooke, Esquire, arrived out of England on the 29th day of June, 1650 in the forty-eighth year of his age with his wife and ten children." He also transported 28 other persons. He received 2,000 acres on the Patuxent River and named it "De La Brooke Manor." The original house was destroyed in the 1800s. (Courtesy St. Mary's County Historical Society.)

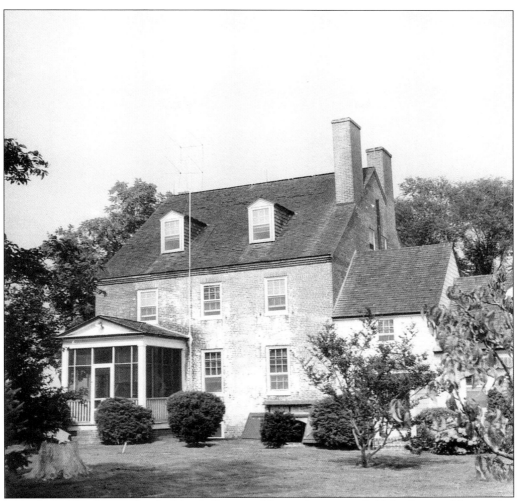

CHERRYFIELDS. Facing the St. Mary's River and located on part of old St. Inigoes Manor, this is the second house located on this site to be called Cherryfields. The first house was the home of Col. Athanasius Fenwick, an officer in the War of 1812. In 1816 Colonel Fenwick married Susan Howell of Philadelphia. They returned to live at Cherryfields, where their three children, James Athanasius, Margaret, and Susan Emeline, were born. In 1824 Susan and Colonel Fenwick both died within six weeks of each other. Their young children went to live with Susan's relatives. Colonel Fenwick is now buried at St. Andrew's Episcopal Church in Burlington County, New Jersey. His tombstone reads, "Col. Athanasius Fenwick, a soldier of the War of 1812, born in St. Mary's County, Md. A.D. 1780, Died A.D. 1824. These remains were removed from Cherryfields, St. Mary's County, Md., their original burial place, by his surviving children A.D. 1874." Cherryfields was later owned by Col. William Coad. The original house was destroyed by fire in 1835 and rebuilt by Colonel Coad in 1836. (Courtesy St. Mary's County Historical Society.)

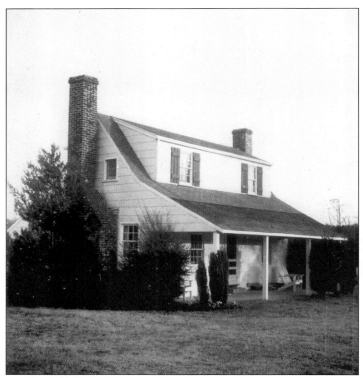

LONG LOOKED FOR COME AT LAST. This property is located in the northern part of St. Mary's County and was owned by John Burroughs, the immigrant ancestor, who was transported in 1669. In 1678 he gave testimony concerning the murder of a neighboring family by Piscataway Indians named Wassetass, Asazams, and Manahawton. Asazams and Manahawton were turned over to the colonists and were immediately tried, found guilty, and "shot to death without delay." (Courtesy St. Mary's County Historical Society.)

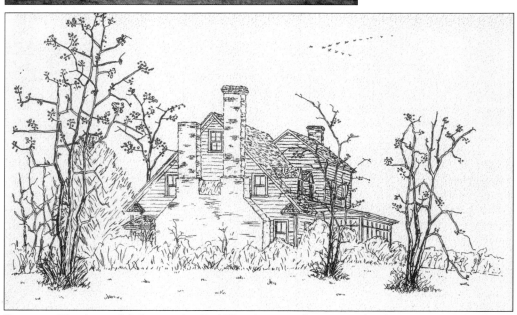

ENFIELD. This beautiful drawing by Carl Kopel was made prior to the destruction of this home in the 1950s. Enfield was located on St. Patrick's Creek. The original part of the house was probably built in the late 1700s. The property, also called Enfield, contained 200 acres and was patented to Thomas Gerard in 1659. It was owned for many generations by his Blackistone descendants. (Courtesy Carl Kopel.)

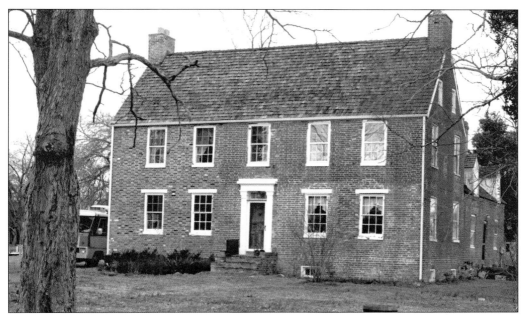

KILGOUR'S TAVERN. Known popularly as Kilgour's Tavern, this house has had many names, including Locke's Tavern and the Stage Coach Inn. When it was bought by William Thomas Briscoe in 1855 and became his residence, it was then known as the Briscoe House. Briscoe was a teacher at Charlotte Hall Military Academy for most of his adult life. His father, Philip Briscoe, who studied law under Francis Scott Key, served twice as principal of the school. (Courtesy St. Clement's Island Museum.)

JESSE GRAY'S LOG CABIN. Little is known about this log cabin, described as "the most photographed house in St. Mary's County," but it may have been one of the old slave quarters at Delabrooke Manor, as there was another slave cabin that stood nearby. The cabin was located just outside the gate of Mt. Zion Methodist Church in Laurel Grove, where Mr. Gray served many years as sexton. The house was destroyed in 1968. (Courtesy St. Mary's County Historical Society.)

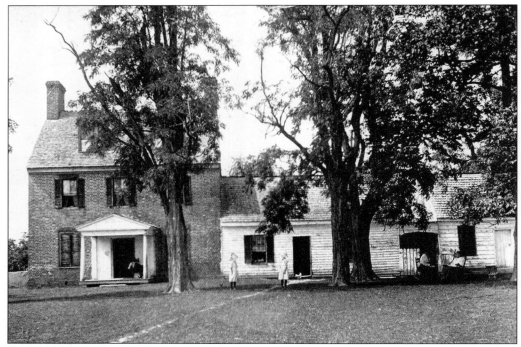

ST. MICHAEL'S MANOR. St. Michael's was the name of one of three large tracts of land granted to Leonard Calvert, Maryland's first governor, that encompassed the entire southern tip of what is now St. Mary's County. This house was built in 1805 by James Richardson and his wife, Levina Loker. This picture was taken about 1900 when the family of Baker Wilmer Herbert lived there. The house is now a bed and breakfast. (Courtesy Gail Valenti.)

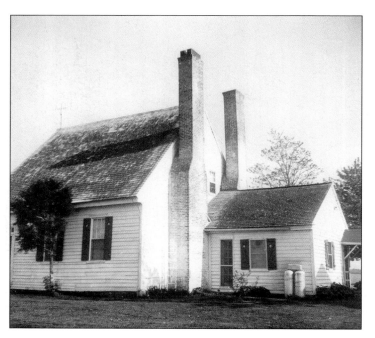

HAWLEY MANOR. Hawley Manor, an early 19th-century home, was reputedly the hideaway of the title character of John Pendleton Kennedy's 1872 novel *Rob of the Bowl*. This work of fiction called attention to the long-forgotten St. Mary's City, abandoned in the late 1600s when Annapolis became the state capital of Maryland. The home is located on St. Jerome's Neck, a point of land bordered by the Chesapeake Bay and St. Jerome's Creek. (Courtesy St. Mary's County Historical Society.)

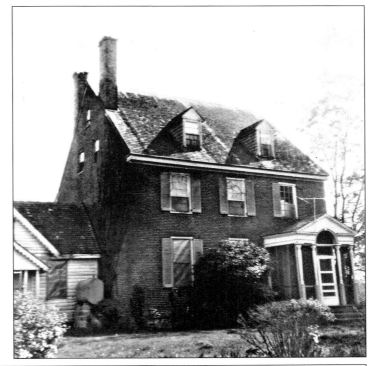

KIRK HOUSE. Built on a portion of St. Gabriel's Manor near the town of Scotland, the Kirk House was built prior to 1798 and was the home of James Kirk and his wife, Ann Biscoe. The Biscoes were among those hard-hit by the British raids during the War of 1812. In July 1813 the British raided them as well as the Smoot, Armstrong, Bennett, Duncanson, Jones, Williams, and Smith families. (Courtesy St. Mary's County Historical Society.)

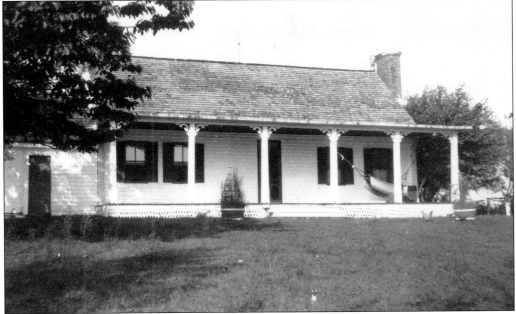

WHITE'S NECK. In 1678 "White's Neck" was deeded to Kenelm Cheseldine by his wife's brother, Justinian Gerard. This house, shown here in 1900, was built by their descendants prior to 1800. It was intentionally set ablaze in the early 1930s by some locals who had it "stacked to the rafters" with moonshine whiskey when the revenuers were spotted. The resulting fire was said to have burned blue for at least three days. (Courtesy St. Mary's County Historical Society.)

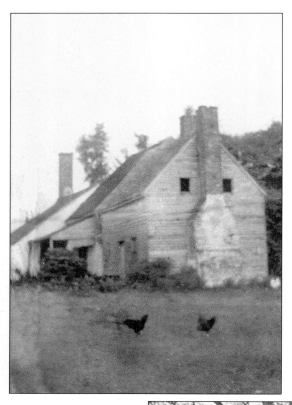

FORREST HALL. There were two homes within the same general area by this name. The one spelled Forest Hall, was the home of Philip Briscoe, located near Harper's Corner. The one shown in this picture was named for the Forrest family and is located near Loveville. Among others of note, Richard Forrest was born here in 1767. He was the first postmaster of Georgetown, D.C., having been appointed by President Washington in 1797. (Courtesy St. Mary's County Historical Society.)

CREMONA. Built about 1819 on part of Delabrooke Manor, Cremona features a suspended staircase and is one of three architectural gems found a stone's throw from the village of Mechanicsville and not far from the Patuxent River. The house was christened "Cremona" by William Thomas, who built it as a dower house for one of his daughters. It was named for an Italian village famous for its violins. (Courtesy St. Mary's County Historical Society.)

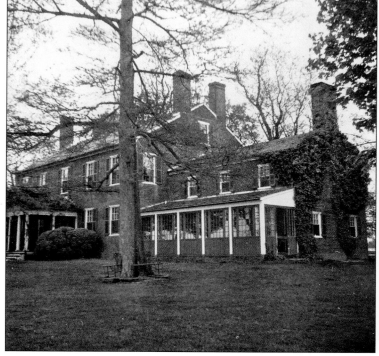

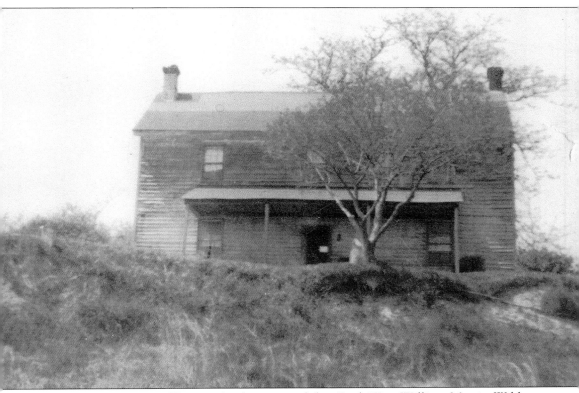

WILLIAM MARTIN WIBLE HOUSE. At the onset of the Civil War, William Martin Wible fought for the South in a Virginia infantry unit. Marylanders crossed the Potomac by the thousands to join the Confederate Army. The exact number of those who served the South will probably never be determined, because many men, fearing retaliation against their families, enlisted using fictitious names. William Wible is an enigmatic figure, but it is known that Union troops, who were occupying St. Mary's County at the time, came to his farm and searched his house from basement to attic. Wible, like many Southern Marylanders, worked for the Confederate underground and hid Confederate soldiers in his barn, providing food and a place to rest for newly escaped prisoners from Point Lookout. When Lincoln instituted the draft in St. Mary's County, Wible reputedly cut off a finger to avoid conscription. An extant photograph of him seems to support this as one finger is indeed missing. Wible was probably also involved in blockade running and signal corps activities as well, but definitive proof is lacking. (Courtesy Joyce Bennett.)

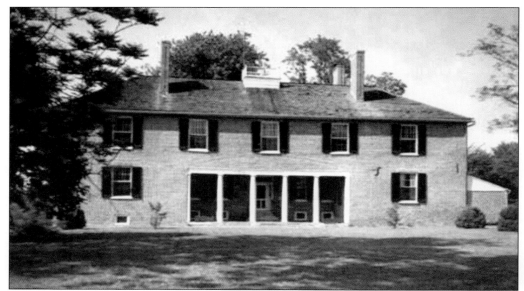

TUDOR HALL. This was the home of Col. Abraham Barnes, who from 1745 to 1754 served as a delegate from St. Mary's County to the Maryland General Assembly. In 1754 he was appointed to represent Maryland at the Albany Congress, whose resolutions, while not adopted, served as the forerunner of the Declaration of Independence some 22 years later. Tudor Hall is the home of the St. Mary's County Historical Society. (Courtesy St. Mary's County Historical Society.)

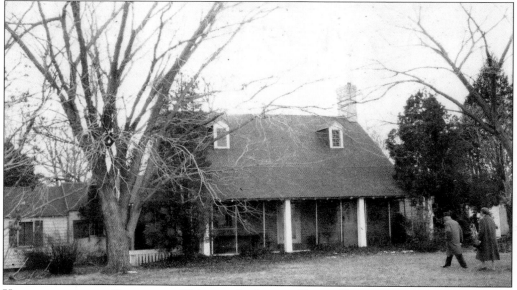

KINGSTON ON THE PATUXENT. This was the home of James King, a sea captain. He was the grandfather of "The Fighting Thompsons," the six sons of James and Nancy (King) Thompson, four of whom served during the War of 1812. John and William were taken prisoner and imprisoned in Canada. Benjamin was killed in 1813 at York, Canada, and Barzillar served in the 12th Regiment of the St. Mary's County Militia. (Courtesy St. Mary's County Historical Society.)

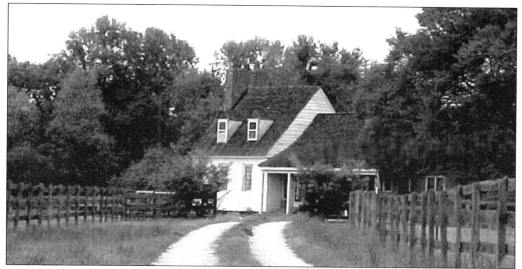

NOTLEY HALL. There was a house at Notley Hall before 1679. The property was originally granted to Thomas Notley, who later sold it to Lord Baltimore. Council meetings were sometimes held here. On March 4, 1681, Capt. Justinian Gerard was ordered to "appear with his Company in Armes on Saturday next the Eighteenth instant in Notley Hall field." This house was built in the 18th century, on or nearby the original site.

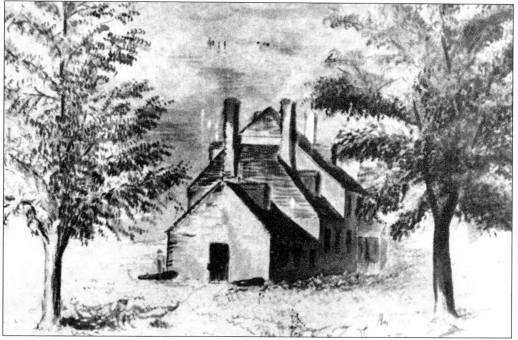

ST. INIGOES MANOR HOUSE. The Society of Jesus bought St. Inigoes Manor from Richard Gerard in 1637. The house was built in 1705 from the bricks of the demolished chapel at St. Mary's City. The manor and other Jesuit landholdings here establish St. Mary's County as the site of the first Catholic mission in the English colonies. Thomas Connelly made this drawing in 1870. The house burned in 1872. (Courtesy Fr. Damian Shadwell.)

PORTO BELLO. Porto Bello was named by William Hebb to commemorate his service in the War of Jenkins' Ear. He served under Adm. Edward Vernon of the Royal Navy and later named his first son Vernon in honor of his commanding officer. A fellow soldier, Lawrence Washington, George Washington's half-brother, named his Virginia plantation in honor of the admiral, calling it Mount Vernon. This is the second house, built about 1812. (Courtesy John D. Ford.)

RIDING TO THE HOUNDS AT TRENT HALL. Trent Hall was built about 1789 by John DeButts, a native of County Sligo, Ireland. Located on the Patuxent River, it stands on the property patented by Thomas Truman in 1657 called Trent Neck. Major Truman served in the Privy Council and the Maryland legislature, and he headed the Maryland militia. Dr. and Mrs. Henry Virts, the current owners, say the property is haunted by Major Truman; they call him "Tom." (Courtesy Henry and Nancy Virts.)

Three
TOWNS AND COMMERCE

Essentially there are really only two towns of any size in St. Mary's County: Leonardtown was the first and stood alone until the 1940s when the U.S. Navy came here. At that time, the second sizeable town, Lexington Park (formerly Jarboesville) began growing by leaps and bounds. Even today, places such as Compton, Ridge, Chaptico, and Helen could, at best, be called villages. Ask any native St. Mary's Countian and they'll tell you that they prefer it that way. It is not unusual to see the names of the ancient properties today on driveway entrances, as people have held onto these names with pride.

Since the beginning, the main occupation in this area has been farming, and until recent years, the primary crop was tobacco. Sadly, farming may soon be a thing of the past, as farmers are paid to not plant tobacco and developers are buying up large tracts on which to build houses. The secondary occupation in the region is fishing, and watermen are engaged in providing seafood up and down the East Coast. Neither job is designed for the faint of heart.

Today the St. Mary's County Chamber of Commerce would probably say that the largest single employer in St. Mary's County is the Patuxent Naval Air Station, but that should be amended to say the U.S. government, as there are carpools, vanpools, and busloads of people living in the northern end of the county who commute daily to every government agency in Washington, D.C.

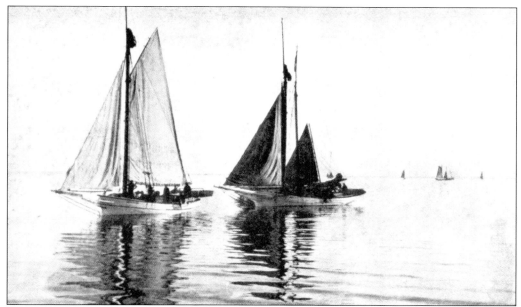

OYSTER FLEET. The beauty and romance of these sailboats is misleading. They are indeed beautiful, but oystering is done during the fall and winter; therefore, not only is the work arduous, but it is cold and dangerous as well. St. Mary's County men have been oystering these waters since the earliest days of the colony, and these rugged individuals have been seasoned by time and tide. (Courtesy St. Clement's Island Museum.)

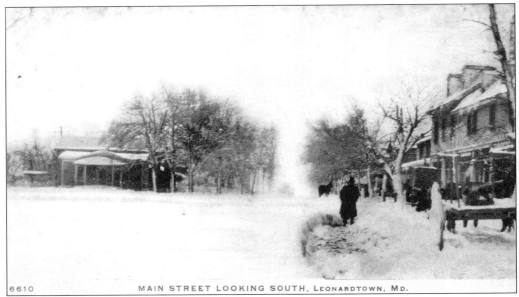

LEONARDTOWN POSTCARD. Leonardtown, originally named Old Shepard's Field and later Seymour Town, became the county seat of St. Mary's in 1708. Picturesque but not always a peaceful little village, during the War of 1812 Leonardtown was occupied by British troops under the command of the infamous Admiral Cockburn. It was occupied again by Union troops early in the Civil War. The town's newspaper, the *Beacon*, was closed down and its editor jailed. (Courtesy Historic St. Mary's City Commission.)

CLIFTON FACTORY. During the War of 1812, with raiding British troops at Point Lookout, St. Mary's militia men were ordered to meet at Clifton Factory to prepare for battle. Established in 1810, Clifton Factory was named after the cotton-manufacturing enterprise located there. By 1834 the Clifton Factory property consisted of a 3-story building, an 11-room tavern, a smokehouse, a dairy, stables, a tailor's house and shop, and several other structures. (Courtesy St. Mary's County Historical Society.)

GARDINER/YOWAISKI MILL. A port of entry in Colonial times, the historic village of Chaptico gives little hint of that today. The natural harbor has, over time, filled in with sediment, and now only marshland can be seen where ocean-going vessels once moored. Chaptico rebounded and by the latter 19th century boasted several business enterprises, including Gardiner's Mill. In later years it was owned by the Yowaiski family and operated into the 1960s. (Courtesy St. Mary's County Historical Society.)

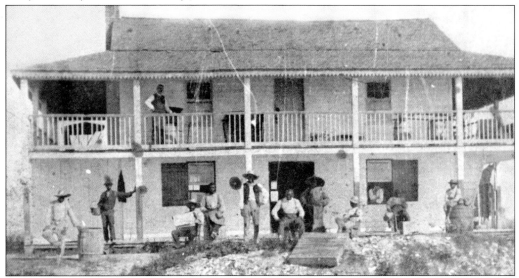

SWANN'S STORE. Located at Piney Point, Swann's store, like others throughout the county, was also a gathering place for the local citizens to meet and greet their neighbors. The area has endured the fury of two major hurricanes and a tragic oil-barge explosion in 1986 that killed four. Swann's store was destroyed by fire in 1817 but was later rebuilt. For many years it also served as the local post office. (Courtesy St. Mary's County Historical Society.)

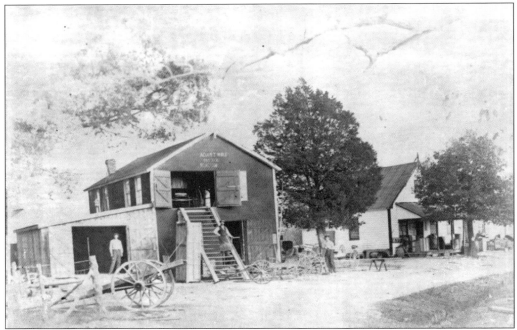

ADAM WIBLE'S BLACKSMITH SHOP. Local writer and legendary wit Adam T. Wible operated a blacksmith shop in Avenue well into the 20th century. Beginning in the late 1800s under the pen name Gabriel, he wrote a weekly column for the *Beacon*, often penning humorous poems that commented on the passing scene in St. Mary's County. (Courtesy St. Mary's County Historical Society.)

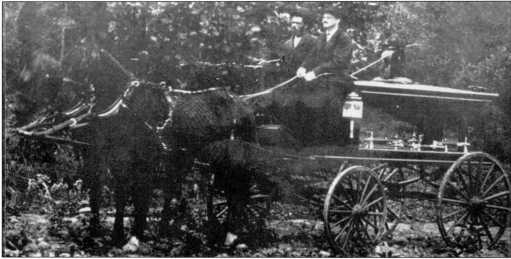

BENEDICT LOVE, UNDERTAKER. Funerals have always been an important part of life here and are occasions of feasting and socializing. In earlier days when churches were not air conditioned, bereaved family members were fanned by ladies from the church. When funeral processions passed, people stopped to pray and men removed their hats to show respect. Even today local residents pull their cars off the road and wait in respectful silence. (Courtesy St. Mary's County Historical Society.)

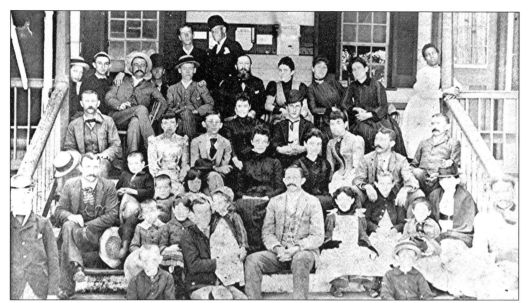

MOORE'S HOTEL. During the War Between the States, Moore's Hotel served as a rendezvous point for Marylanders "absconding" across the Potomac to fight for the South. One former Confederate wrote in his memoirs that he traveled here from Pikesville, Maryland, to join the Confederate forces. When he arrived he was introduced to a Mr. Moore, who ran a hotel where at least 25 men were waiting for the next ferry to Virginia. (Courtesy St. Mary's County Historical Society.)

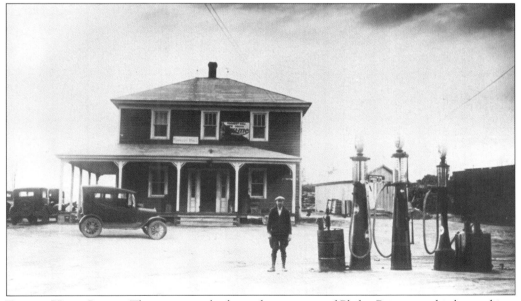

FOREST HALL STORE. This store was built on the property of Philip Briscoe and is located just south of Harper's Corner Road. When trains came, it was a whistle stop. Melvin Wood is shown standing here in the early 1920s. The Wood family ran this store for many years until the early 1950s, when it was closed. It was recently renovated and converted into apartments. (Courtesy Ashley Hill.)

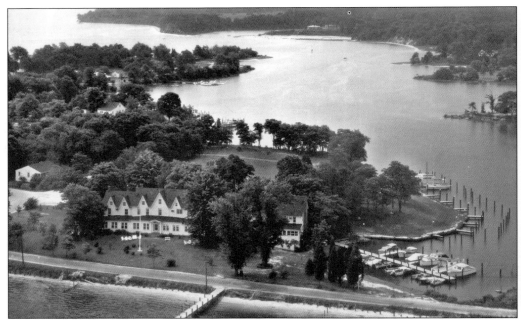

SEVEN GABLES HOTEL. Located on the Patuxent River in an area long ago known as Spencer's Wharf, Seven Gables Hotel, one of St. Mary's architectural treasures, was torn town in 1990 and is now the site of a boat-storage facility. Spencer's Wharf was formerly the property of J. Parran Crane, a Confederate soldier and circuit court judge who is buried in nearby historic St. Andrew's Episcopal Church. (Courtesy United States Navy.)

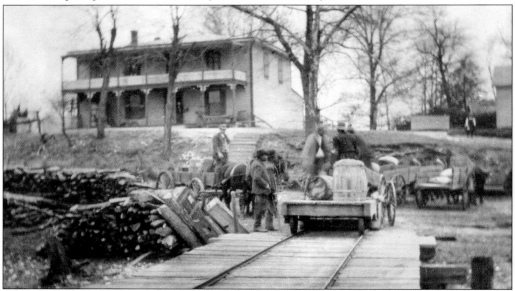

MILLSTONE LANDING. Millstone Landing was a port of entry from Colonial times. According to local historian Regina Combs Hammett, it was "one of the busiest steamboat landings during the 1820s-to-1930s period of St. Mary's County history." Millstone Landing served briefly as a ferry-boat wharf in the years just preceding World War II. (Courtesy St. Clement's Island Museum.)

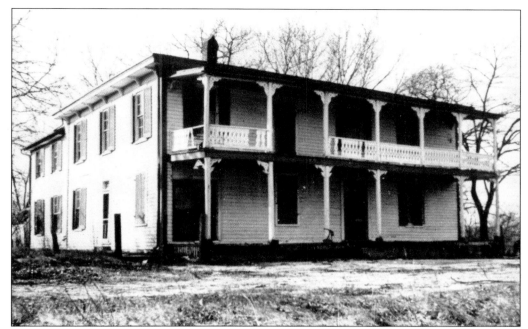

CRADDOCK'S STORE. This store was located on the top of the hill at Millstone Landing and is visible in the previous picture. It was owned by Joseph Clement Craddock, who was originally from Kent County. He was in St. Mary's County by 1869 when he married Rosetta E. (Milburn), widow of Samuel G.M. Burroughs. Mr. Craddock died at Millstone Landing in 1926. (Courtesy United States Navy.)

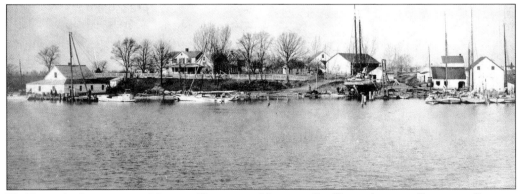

H. EWELL'S STORE AND MARINE RAILWAY. Harrison Ewell was born in Somerset County, Maryland, in 1865 and was in St. Mary's County by 1900. This picture of his business at Compton was taken c. 1908. Mr. Ewell died in 1936 and his wife in 1945. They are both buried at St. Paul's Methodist Church in Leonardtown. (Courtesy Historic St. Mary's City Commission.)

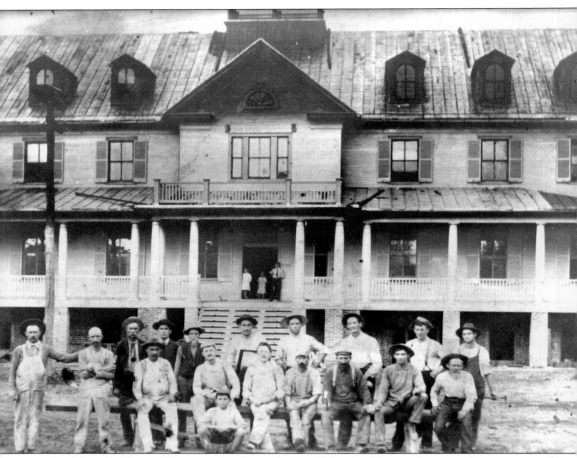

St. Mary's Hotel Workers. In the tradition of Maryland hospitality, travelers were warmly welcomed in old St. Mary's County. In 1910 a *Baltimore Sun* correspondent described the accommodations at the Hotel St. Mary's in the following passage:

> The writer arrived late in the evening. . . . It was long past the supper hour and he craved a little lunch. . . . The landlord made copious excuses for what he might serve his guest at that hour, but thought he could manage it. . . . What the traveler really got was a dish of frogs' legs, a section of luscious shad, soft crabs done to a turn, a shad roe, Maryland biscuits, hot cornbread, a salad and coffee. And all this was at the rate of only 50 cents for the meal.

In 1911 the *St. Mary's Beacon* considered it noteworthy that 10 cars were parked in front of the hotel—the world had discovered St. Mary's County. In the fall of 1917 a banquet and a ball were held there in honor of the young men of the county who were going off to war. Participants danced the "one-step" to the music of Darroch's Orchestra. (Courtesy St. Mary's County Historical Society.)

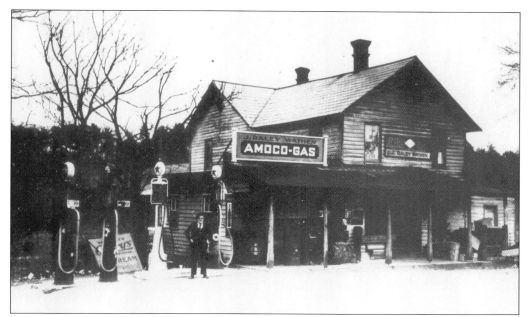

J. Raley Wathen Store. J. Raley Wathen's Store still stands and is located in Morganza on property once called "St. Joseph's Woodland," owned by the Morgan family, from which the area gets its name. Raley's wife, Frances Morgan Knight, was a Morgan descendant. The store is located between the site of the current St. Joseph's Catholic Church and the Old St. Joseph's Church cemetery; it was long neglected but in recent years has been restored and well maintained. (Courtesy Historic St. Mary's City Commission.)

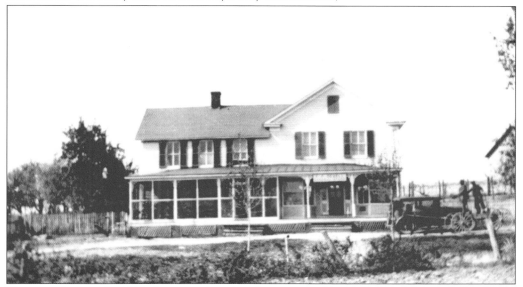

Hopkins Store. In 1900 this was a boarding house owned by Nicholas Hopkins and his wife, Mary Frances (Harding). In 1904 the Oraville post office was established here, named for their daughter, Ora. By 1910 Mrs. Hopkins was operating a millinery shop, and by 1920 it was a general merchandise store. In 1935 the property was sold to Blake and Frances Newell, who lived here until 1959. Mrs. Newell was also postmistress. (Courtesy the Newell family.)

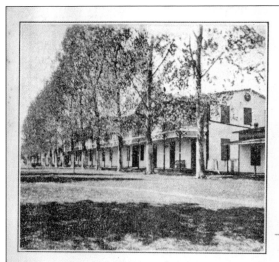

Hotel at Piney Point

PINEY POINT HOTEL POSTCARD. Many years ago Piney Point was a resort area known for its pristine beaches and was a favorite haunt of famous American statesmen as well as local residents. Presidents Monroe and Pierce and Sen. John C. Calhoun of South Carolina vacationed there and fished the waters off of Piney Point. The hotel no longer stands. (Courtesy St. Clement's Island Museum.)

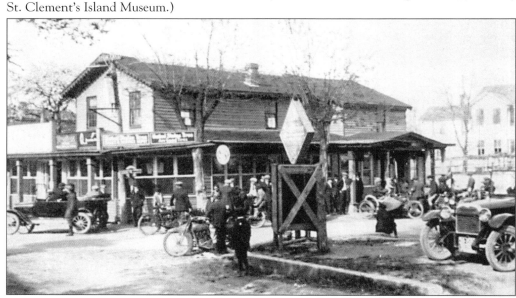

HERBERT'S STORE, MECHANICSVILLE, 1921. James Washington Herbert (1880–1958) was recorded as a hardware merchant at the time of the 1910 and 1920 censuses. This 1921 photo was taken at his store, apparently a hubbub of activity. Mechanicsville was named in honor of two local carpenters, called "mechanics" in the 19th century. Located in northern St. Mary's County, not far from Maryland Route 5, the village was a railway terminus bustling with hotels and businesses in its glory days. It even had its own undertaker. (Courtesy J. Roy Guyther, M.D.)

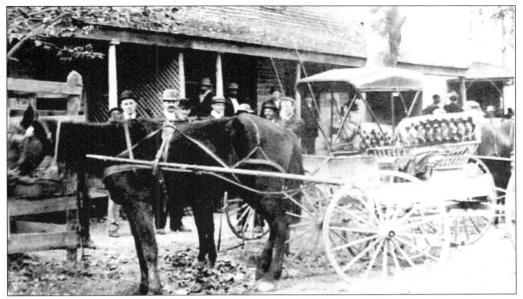

LEONARDTOWN STORE. This postcard from about 1880 shows what must have been an unusually busy day at the store. The gentleman with the black hat standing behind the horse is identified as David W. Hammett, who along with his twin brother Daniel, was a Confederate soldier. Sons of John Hammett and Ann Wilkinson, they were descendants through their mother of William Wilkinson, who was listed as a resident at St. Clement's Manor in 1672. (Courtesy Scott Lawrence.)

FARMING THE OLD FASHIONED WAY. Farmers here have not used this method since early in the last century, but this picture taken of a young Amish man in his field near Charlotte Hall gives us an idea of how things used to be. The Amish sell their products, all homegrown and homemade, at the Farmer's Market twice weekly. This includes freshly churned butter, eggs, fresh fruits and vegetables, jams, jellies, quilts, and baked goods.

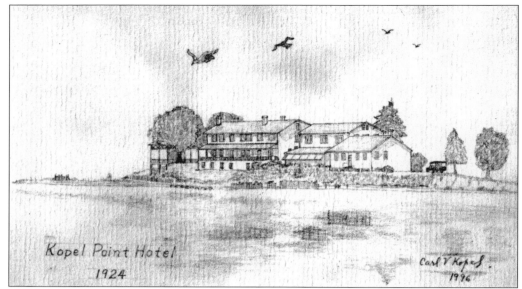

KOPEL'S POINT HOTEL. Harry Kopel immigrated to the United States from Austria as a young man and worked as a maitre'd at the old Willard's Hotel in Washington, D.C. In 1924 he and his wife Elsie converted the old Enfields house, shown here, to a summer guest hotel that they operated until a major hurricane hit the area and destroyed the pier, pavilion, screened dining area, and cottages in 1933. (Drawing by and courtesy of Carl Kopel.)

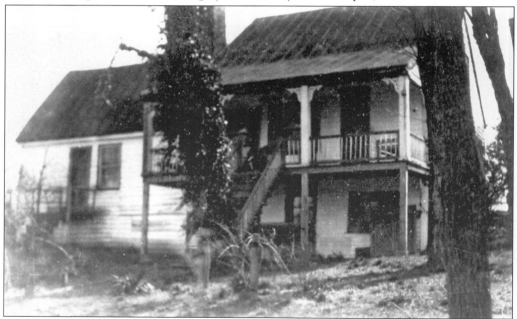

FENWICK TAVERN. Fenwick Tavern, which formerly stood near present-day Hillville according to historian Robert E.T. Pogue, was said to have been haunted by "two old ladies dressed in black." The tavern served as a post office from 1821 to 1865 and was once the home of James Thomas King, who provided lodging to "drummers." It is believed that cock fights were held in the basement of the inn. (Courtesy St. Mary's County Historical Society.)

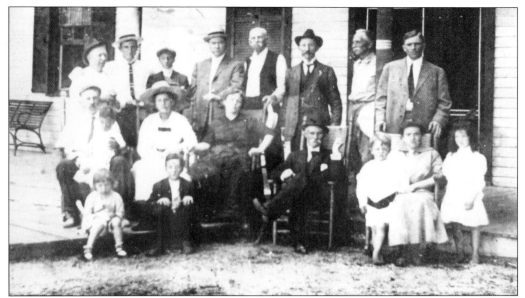

TOLSON'S HOTEL. Warren Tolson purchased the Piney Point peninsula in 1905 for $7,750, built a hotel and a dance pavilion, and subdivided the property for summer cottages. The pavilion proved popular with both vacationers and local residents. Regina Combs Hammett writes, "[The] *Beacon* contains accounts of special steamboat excursions to Piney Point and of sleepy travelers returning to Leonardtown after dawn and a night of dancing." (Courtesy St. Mary's County Historical Society.)

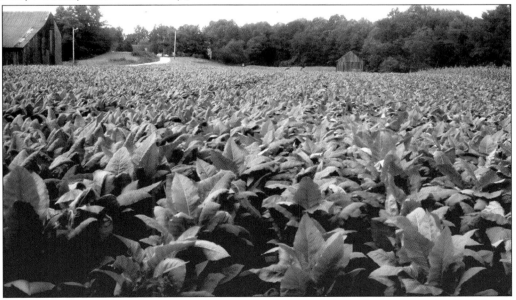

TOBACCO FIELD. Though cotton, wheat, and other crops have been grown in St. Mary's, tobacco was the chief crop for over 350 years. Because of a recent state-sponsored tobacco buyout program, there are only a handful of tobacco farmers remaining in the county, and only a few lush green tobacco fields can still be seen along county roads. This photo was taken at the farm of James Gibbons Wood, near Mechanicsville. (Courtesy Joyce Bennett.)

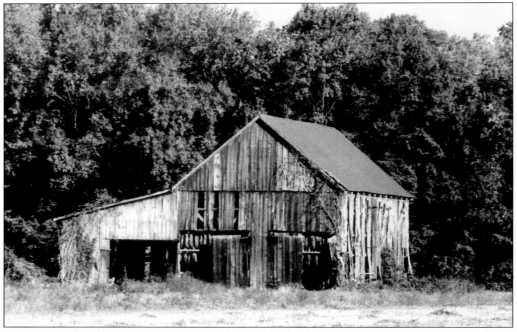

BARN. Weather-beaten, wisteria-covered, gray-hued tobacco barns—some ancient—still dot the landscape in St. Mary's County. As tobacco growing dies out, many barns have been destroyed, some are painted and used for new purposes, and others are simply abandoned and succumb to decay as quiet reminders of Maryland's Southern agrarian past. (Courtesy Joyce Bennett.)

CHAPPELEAR MILL. By his will in 1820, John Dent Chappelear devised to his children "all of my right, title, and interest in 'Trent Neck' located in St. Mary's County near the Cool Springs and where my dwelling and water mill stands containing 300 acres and a pair of mill stones now at Benedict." The same millstones were located some years ago half-buried on a nearby farm. (Courtesy J. Roy Guyther, M.D.)

Four
CHURCHES AND SCHOOLS

Founded as a Catholic colony but offering religious freedom to all, the people of St. Mary's County have always looked to their faith to sustain them in good times and in bad. When a church building was not available, the religious met in homes. When the Catholic churches were closed in the early days of the colony, followers continued to worship, albeit in secret. Today many do not attend church because it is too early or it is too far, forgetting that people in the early days risked their lives for the freedom we take for granted today.

Obtaining an education was also a major task. Generally only the gentry could afford to send their children to school, and given the lack of schools in the colonies, many children were sent to Europe to be educated. Such was the case of Dr. John Hanson Briscoe, who was sent to Scotland about 1759 at the age of eight. One can only imagine how lonesome and scary it must have been for this little boy to be so far from home. A hundred years and even 150 years later, while there were more schools, there were still major barriers to overcome. For these children, there would be 20 or 30 children in a one-room school, a lack of books and other supplies, and no transportation. Then again, many children simply could not go to school because they were needed on the farm, not to enrich the family but to ensure its survival.

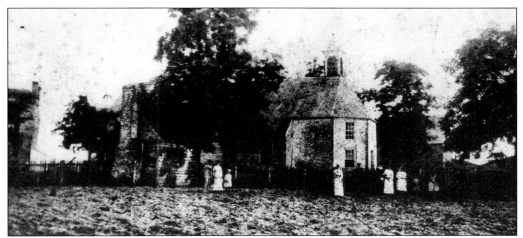

ST. FRANCIS XAVIER, NEWTOWN. A Catholic mission was established at Newtown about 1639. A church was not built at the site until about 1662, on part of the Manor of Little Bretton granted to William Bretton by Lord Baltimore in 1640. The first church built here was located in the vicinity of the present-day cemetery. The second church, with the exception of the confessional, was built in 1766 and is located a short distance away. (Courtesy Historic St. Mary's City Commission.)

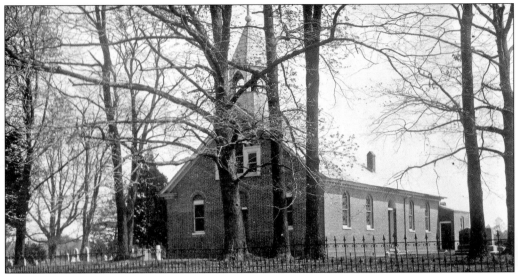

ALL FAITH EPISCOPAL CHURCH. All Faith Parish was created in 1692. The church shown here was built in 1767; however, the steeple was destroyed by Hurricane Hazel in 1954. One of the earliest rectors was Rev. Robert Scott of Kent, England, who received the bounty to Maryland March 10, 1707 or 1708, and served until his death in 1733. In 1722 he was described by the Bishop of London as "A Whig & a good Christian." (Courtesy Bill and Patty Poffenbarger.)

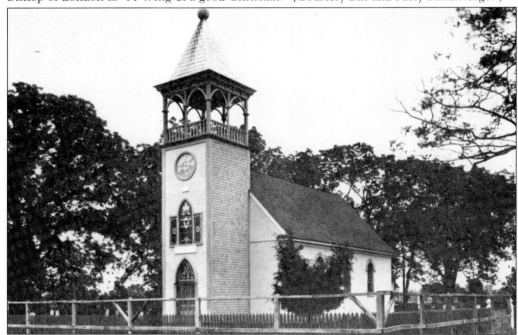

ST. IGNATIUS CATHOLIC CHURCH. The original portion of this church was built in 1785 on St. Inigoes Manor within sight of the manor house; it replaced a frame church built nearby in 1745. In 1814 the manor house and chapel were both robbed and pillaged by the crew of a British ship. After residents complained, some items were returned but loss estimates still exceeded $1,200, a huge sum for that time. (Courtesy Fr. Damian Shadwell.)

JOY CHAPEL, 1894. In 1832 Miley Jones attended a Methodist camp meeting in Calvert County and converted to that faith. Later he traveled around the Hollywood area, holding prayer meetings and conducting Bible studies. In 1851 James Joy also converted to Methodism and opened his home to meetings. The first Joy Chapel was built on Mr. Joy's farm in 1868 and was replaced by this one in 1894. It burned in 1931. (Courtesy Hollywood United Methodist Church.)

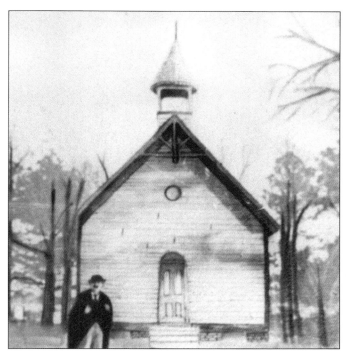

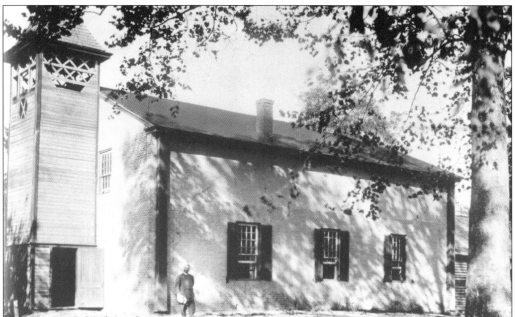

OUR LADY'S CHAPEL, 1819. The chapel shown here was built in 1819 and replaced one built in 1766. Some had complained from the beginning that the foundations of this new church were defective. In 1830 there was an unusually large crowd attending Mass when one of the floor supports began to give way. Panic ensued and many parishioners were cut and bruised while trying to escape the building. Extensive repairs were completed by 1831. (Courtesy St. Mary's County Historical Society.)

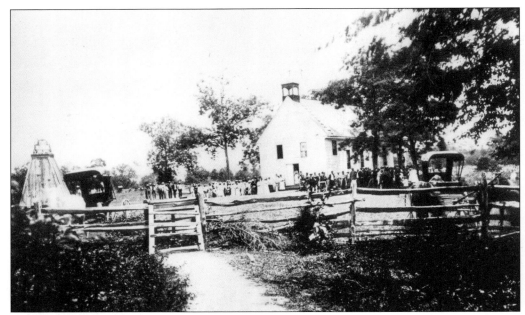

St. Nicholas Catholic Church. This is the second St. Nicholas Church, built about 1795. A wooden chapel was at Mattapany prior to 1698. Fr. Sebastian DeRosey served here from 1807 until his death in 1812. Since he died intestate, the proceeds of his estate went to Charlotte Hall School for educational purposes. The church now standing was built in 1916. It is used as the Base Chapel by the navy and is non-denominational. (Courtesy Scott Lawrence.)

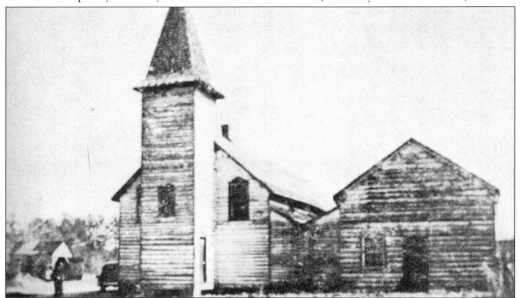

Holy Face Catholic Church. This Catholic parish at Great Mills was established in 1879, but it would take eight years of fund-raising activities to erect this church, built in 1887. Until that time parishioners met in a one-room village store that was converted into a chapel. This old church still stands, but it was abandoned in 1940 when a new one was built. (Courtesy Fr. Damian Shadwell.)

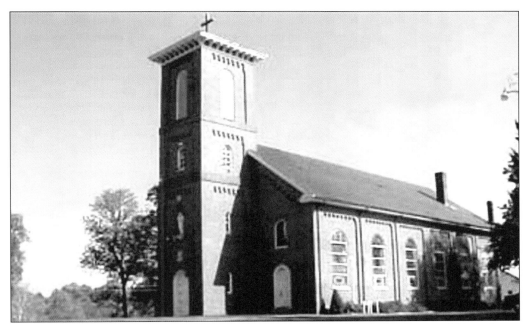

ST. JOSEPH'S CATHOLIC CHURCH. The building of this church began in 1858 and was completed in 1864. The land for the church was donated by George H. Morgan. It replaced an earlier church, said to have been built about 1740 and located about 300 yards south at the site of the Old St. Joseph's Cemetery. It is located in Morganza, which is said to be named for the Morgan families who lived there.

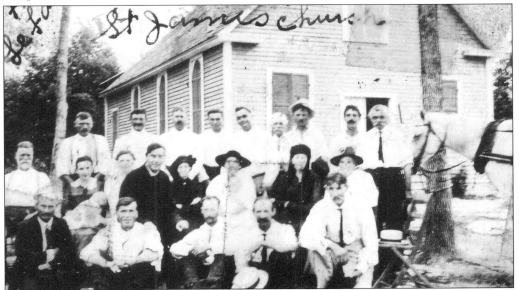

ST. JAMES CATHOLIC CHURCH. This church was located near St. Mary's City and was built in 1915 by newly arrived Slavic immigrants and some local St. Mary's Countians. The building was used as a chapel, parish hall, and school. It was destroyed in 1974. This picture, probably taken shortly after it was completed, shows the first members of the church. (Courtesy Fr. Damian Shadwell.)

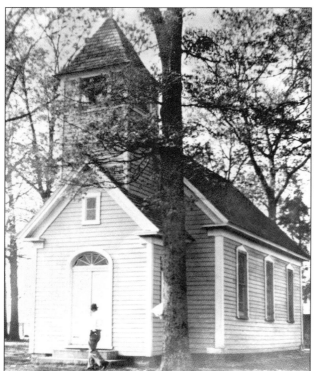

CEDAR POINT METHODIST. This church was built in 1879 on land donated by Henry Jones. James Shade of Park Hall donated logs and sawed them into timbers. The Fish family and others donated labor and materials. The church was demolished in 1942 when the navy took over the property. The remains of those buried there were moved to Ebenezer Church. (Courtesy St. Mary's County Historical Society.)

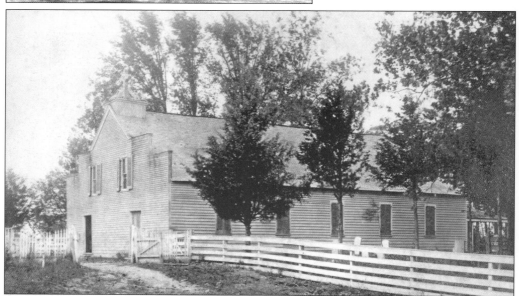

SACRED HEART CATHOLIC CHURCH. This was the second church built in 1892 on the same foundation as the original, which existed before 1773. It burned in 1946 after being struck by lightening. Probably the earliest intact tombstone here is that of Susanna Tennison, wife of James Morgan. She was born in 1758 and died November 12, 1795. Her tombstone reads, "Susanna by thy worth, remembered by the just and be thy frailities buried in the dust." (Courtesy St. Mary's County Historical Society.)

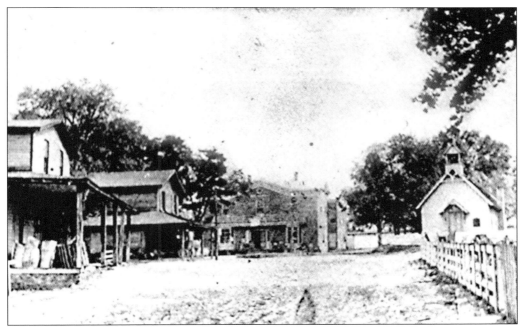

CHAPEL OF EASE—ALL FAITH. This charming picture was taken in what is now the old part of Mechanicsville about 1913 and shows the little chapel that was built there in 1886. Constructed to serve members of the All Faith Parish who lived in the Mechanicsville area, it stood as a proud member of the community until it was dismantled in 1946. (Courtesy J. Roy Guyther, M.D.)

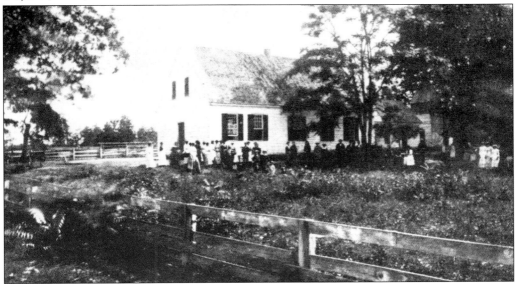

ST. JOHN'S CATHOLIC CHURCH, 1788. This was said to be the second church at this site, and while it is dated 1780, some say it was built prior to the Revolutionary War. The St. John's Parish has served the Hollywood community well. One elderly St. Mary's Countian remembers church festivals at St. John's in the 1930s. Although times were hard, there was plenty of cake, ice cream, and soft drinks for the children. (Courtesy St. Mary's County Historical Society.)

MT. ZION METHODIST CHURCH. In 1810 Joseph Harding bought "Part of Fawskirk" and "Part of Haphazard" from Thomas Attaway Reeder. In 1823 his son, John Ellis Harding, gave part of this property to Benjamin Tippett, a Methodist circuit rider, for the purpose of erecting a church. The first Mt. Zion Church was built there perhaps by 1824. The church shown in this drawing was built in 1914 after the first one was accidentally burned. (Drawing by and courtesy of Sandy Geisbert Ondrejcak.)

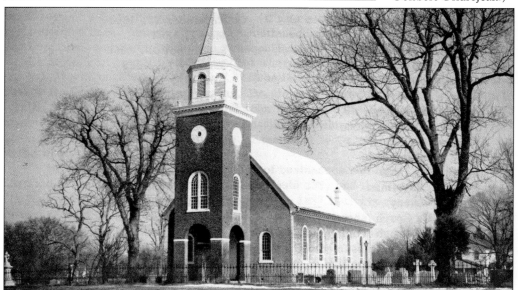

CHRIST EPISCOPAL CHURCH, CHAPTICO. Built in 1736, this historic church still stands. When British forces invaded Chaptico in 1814, Admiral Cockburn said, "[W]e took quiet possession without opposition." Unfortunately, this was not true. Atrocities included using sunken graves as barbecue holes, using the communion table as a dinner table, destroying the organ, using the church as a stable, breaking into tombs seeking treasure, and forcing young women to strip naked before the officers. (Courtesy Maryland Historical Trust.)

THE RED CHURCH. This drawing shows what the Red Church may have looked like when it was built. All that remains are a few hand-hewn timbers, the 1767 cornerstone, the stone chimney, and several unmarked graves. Originally built as a chapel of east of All Faith, in later years it was also used by Methodists. It lies abandoned near Laurel Grove and if not claimed soon will be lost to us forever. (Drawing by Joshua K. Humphries.)

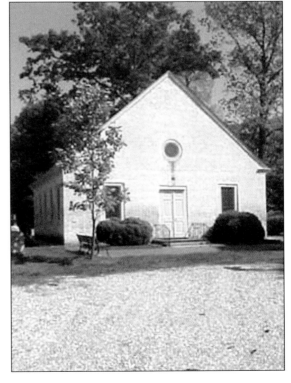

ST. GEORGE'S EPISCOPAL. St. George's Episcopal, also called Poplar Hill, is the second church at this site and was built about 1799. The tombstone of Rev. Francis Sourton, who served as rector from 1663 until his death in 1679, is in the church itself. His tombstone (in Latin) reads, "Francis Sourton, Anglican of Devonshire, son of Francis, minister of evangelic truth. He was sedulous in a life often afflicted and was buried in 1679."

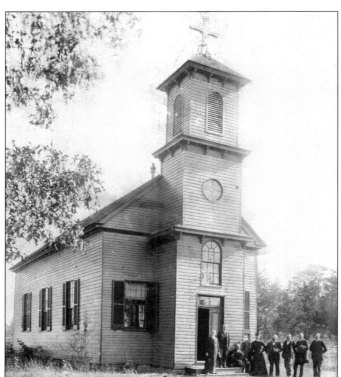

ALL SAINTS EPISCOPAL, 1890. All Saints was established as a Chapel of Ease in 1750. This second church was built in 1846. Richard Brown, eldest son of Dr. Gustavus Brown, was the minister here until 1773, when the parishioners forced him to resign. He had murdered one of his slaves and then fled to Virginia until his son, "who could be the only positive Witness against him could be ship't away thence to Scotland." (Courtesy David Cummins.)

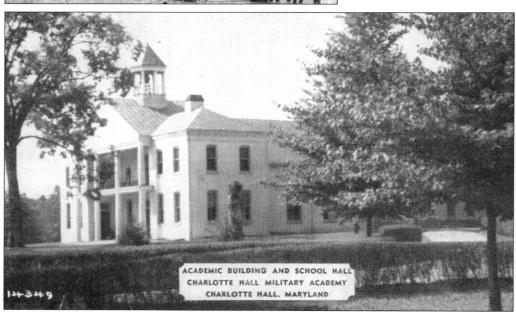

CHARLOTTE HALL SCHOOL. In 1773 the General Assembly of Maryland passed an act providing for the erection of a school at the place called "The Cool Springs in St. Mary's County, to be called Charlotte Hall." Funding problems, land acquisition, and the onset of the Revolutionary War caused delays, and the school would not be opened until January 19, 1797. It closed in 1976 after 179 years. (Courtesy Charlotte Hall School Archives.)

COLIN FOOTE BURCH. Born September 18, 1891, in St. Mary's County, Colin Burch was the son of Edward Albert Burch and Jennie Lomax. This picture was taken in 1910 in his senior year at Charlotte Hall School. He was valedictorian of his class, and it was noted that he had the highest grade average of anyone for many years at that school. Mr. Burch served as a first lieutenant during World War I. (Courtesy Charlotte Hall School Archives.)

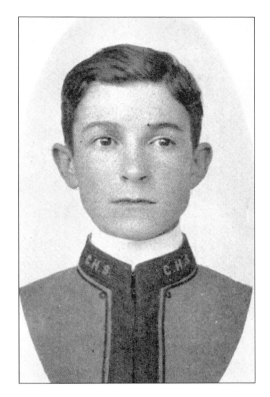

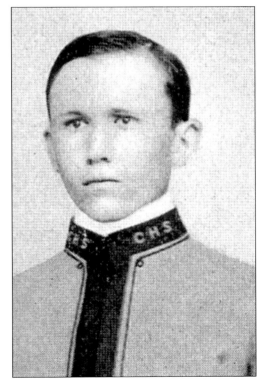

JAMES ARTHUR DAVIS. A graduate of Charlotte Hall School in 1909, James Davis was the son of Philip Henry Davis and Ann Elizabeth Bond of "Trent Hall." The caption under this picture of him as a senior notes that he "has a lovely voice and sings by the hour" and that among his worst habits were poker playing and "chewing terbacker." He later became an attorney and lived in Silver Spring, Maryland. (Courtesy Charlotte Hall School Archives.)

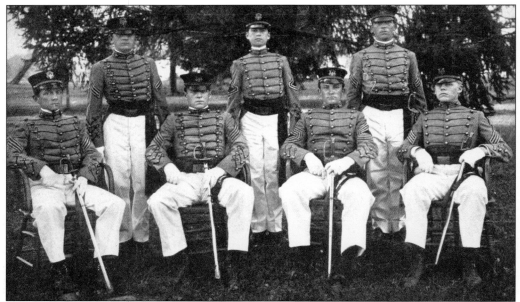

COMMISSIONED OFFICERS. James Sothoron Gough, born September 18, 1891, and Arthur Page Gough, born July 27, 1893, sons of Richard Gough and Annie L. Sothoron of "The Plains," are shown here in this 1911 picture taken while they were attending Charlotte Hall School. The brothers both served during World War I. James was located at various camps within the United States, while Arthur would see action at the front in France. (Courtesy Charlotte Hall School Archives.)

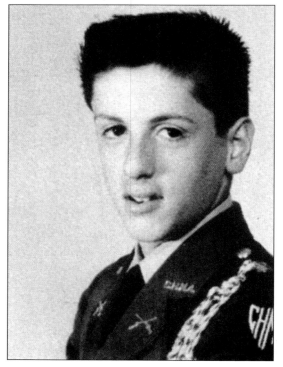

SYLVESTER STALLONE. Sylvester Stallone attended Charlotte Hall School for just one year. This picture shows him, at the age of 15, as a member of the freshman class of 1961. J. Roy Guyther, M.D., who was the attending physician for the school for many years, recalls that it was obvious that Sylvester did not enjoy his time at Charlotte Hall as he was frequently on sick call. (Courtesy Charlotte Hall School Archives.)

FRANCIS HARVEY BAILEY. The son of James Henry Bailey and his second wife, Julia Charlotte Russell, Francis Bailey graduated from Charlotte Hall School in 1910. The yearbook refers to him as an "orange-topped genius who ranks high in respect of the faculty. He has a series of war-whoops which he practices after taps and before reveille." Bailey was later a farmer and lived in the seventh district. (Courtesy Charlotte Hall School Archives.)

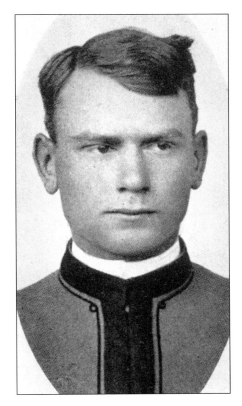

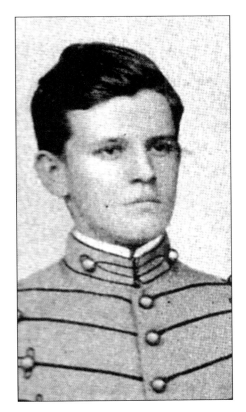

JOHN FRANCIS DENT. Born at Denton Farm in Oakley, John Dent was the son of Dr. Walter Dent and Eleanor Blackistone. The caption under this 1909 senior picture says, "His beauty has attracted many of the fair sex. Is a fine scholar and always aims to get a hundred in demerits." He was a descendant of John Dent, born in Yorkshire, England, who died in St. Mary's County in 1712, and his wife, Mary Hatch. (Courtesy Charlotte Hall School Archives.)

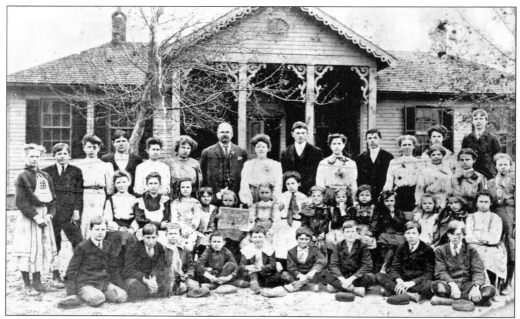

LEONARDTOWN SCHOOL. In this picture taken on April 25, 1906, is what appears to be the three-room school erected in Leonardtown in 1881 at a cost of $1,219.50. Regina Hammett says that only two of the three rooms were used for classrooms prior to 1900. The children in this picture are, unfortunately, not identified. (Courtesy St. Mary's County Historical Society.)

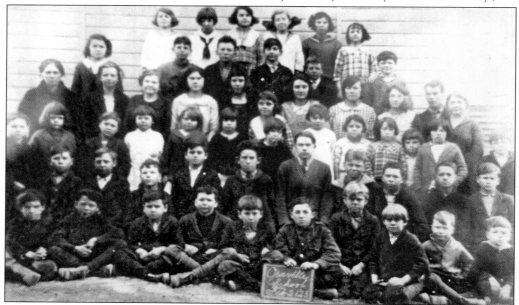

ORAVILLE SCHOOL, 1923. This one-room school was located just a few yards off Route 235 on Route 6. It was said to have had the best drinking water anywhere in St. Mary's County from a freshwater spring located just behind it. Pictured here in the fourth row at far left is the teacher, Mrs. Mamie (Dyson) Buckler (1883–1945). This school closed in 1951 with the opening of Mechanicsville Elementary School. (Courtesy Jay R. Long.)

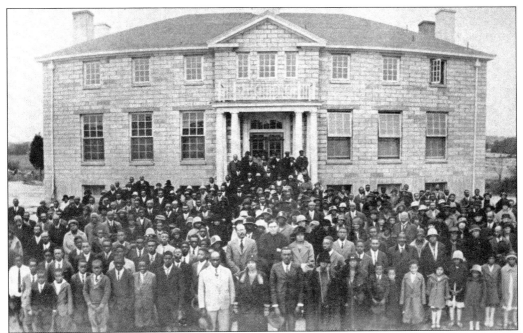

CARDINAL GIBBONS INSTITUTE. This was a Catholic school and the first high school for African Americans in St. Mary's County. Located on 180 acres at Ridge, it opened in 1924 with an enrollment of 28 students. Lack of funds caused by the Depression forced suspension of classes from 1933 to 1938, but the school reopened and operated continuously until 1967. The building was torn down in 1972. (Courtesy Fr. Damian Shadwell.)

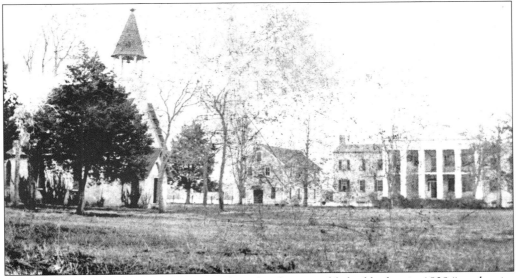

ST. MARY'S FEMALE SEMINARY, 1898. This school was established by law in 1839 "on the site of the ancient City of St. Mary's." It operated as a school for girls until 1930. Today it is known as St. Mary's College of Maryland, a four-year liberal arts college recently ranked as one of the top 100 colleges in the United States. To the right is Calvert Hall, built in 1845. Trinity Episcopal Church is on the left. (Courtesy St. Mary's College of Maryland Archives.)

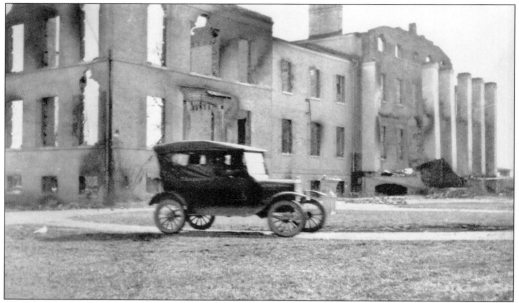

AFTER THE FIRE. On January 5, 1924, the day before the students were scheduled to return to school from Christmas vacation, the main seminary building at St. Mary's was gutted by fire, as can be seen from this picture taken a few days later. Within two weeks a temporary building was constructed, and within four weeks the school reopened. By August 3 of the same year, the new seminary building was completed. (Courtesy St. Mary's College of Maryland Archives.)

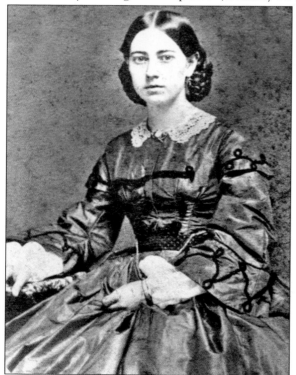

THEODORA MARY ANDERSON. Born in 1840, Theodora Anderson was undoubtedly named for her father, Theodore Anderson. Her mother was Adeline Margaret Knott of St. Mary's County. Her father died when she was very young, and her only sibling, Adeline Augusta Anderson, died in 1853 at the age of 20. Theodora married James B. Norris, whose mother was Jane Attaway Biscoe, also of St. Mary's County. Theodora attended St. Mary's Female Seminary in the 1850s. (Courtesy St. Mary's College of Maryland Archives.)

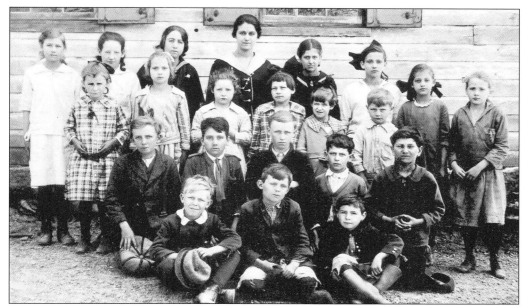

GRAVELLY HILL SCHOOL. This school was located at Medley's Neck, and shown here is the class of 1919–1920. The teacher was Mary Olivia Raley, located in the back row, fourth from left. Miss Raley was the daughter of John Francis Raley and Lucy Roberta Dawson. She later married Joseph C. Abell. She died in 1970. (Courtesy Historic St. Mary's City Commission.)

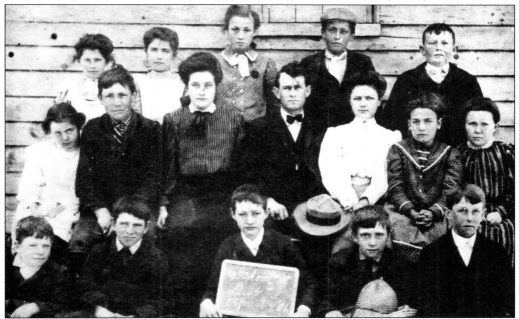

CLEMENTS SCHOOL, 1906. The teacher of this class, Claude E. Guy, is shown sitting in the middle of the second row with his hat on his knee. Guy graduated in 1900 from Charlotte Hall School, tried his hand for a couple of years at being a traveling salesman, and then began teaching at this school in 1902, staying until 1910 when he quit to run his own successful businesses. (Courtesy St. Mary's County Historical Society.)

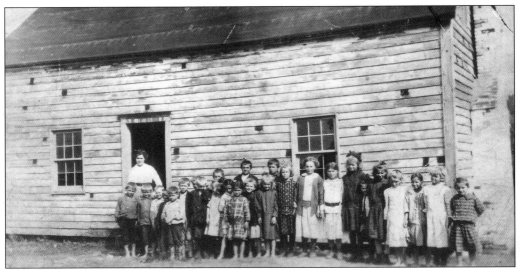

St. Mary's City School. This picture was taken about 1915. The school was located in the vicinity of St. Mary's City. With the exception of Thomas and James Knott (14th and 15th from left) the rest of the students shown here were members of a group of Slavic immigrants who arrived in St. Mary's County between 1911 and 1914, buying over 2,000 acres on which to establish a community. The teacher during this time was Katie Johnson. (Courtesy Historic St. Mary's City Commission.)

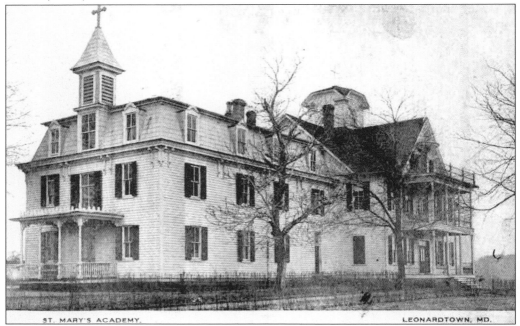

St. Mary's Academy. In 1885 this school was established at Rose Hill, a farm purchased and donated by Richard H. Miles and his wife specifically for opening a Catholic school. The Sisters of Charity of Nazareth, Kentucky, agreed to accept the challenge, and this school for girls opened the same year with 17 students enrolled. It was nationally and internationally recognized for the quality of education provided. (Courtesy St. Mary's County Historical Society.)

Four
By Land, Sea, and Sky

Transportation during the early days of Maryland was conducted two ways, by foot or by boat. Even though transportation was hard and dangerous, colonists traveled a good bit and were fairly mobile for the time. There was much travel back and forth between the Maryland settlers and people along the Virginia coastline. The same holds true for travel up and down the Chesapeake Bay and the other tributaries. Furthermore, wealthy planters often traveled back and forth to England.

It would be many years before typical, early Colonial families could afford to have a horse or an ox, but whether they had them or not was irrelevant. These animals were not for riding; they were for work. The only other task that a horse might perform would be hauling the family in the wagon to church on Sunday.

In later times, riding the large steamboats from here to Washington or Baltimore must have been a thrilling experience, not just for the ride, but to see an actual city! The sights and the sounds must have been almost overwhelming. People were probably not as thrilled when the automobile came along because of the lack of highways. Owners likely spent more time digging them out of the mud and repairing broken wheels than they ever spent driving the contraptions. Today we drive our modern cars, ride the subways and high speed trains, jet off to Europe, and don't think twice about it.

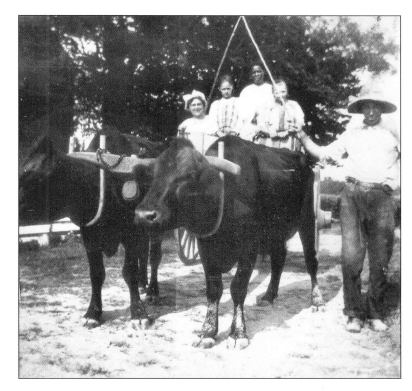

Ox Cart. In the 1940s oxen were still widely used by farmers, but by the 1950s Wilmer Mason is said to have owned the last working team of these animals. A pair of oxen, hitched together with a special yoke, pulled carts loaded with hay and tobacco and also "snaked" logs from the forest. Some farmers felt great affection for them and gave them such sentimental names as Cinnamon and Lemon. (Courtesy Historic St. Mary's City Commission.)

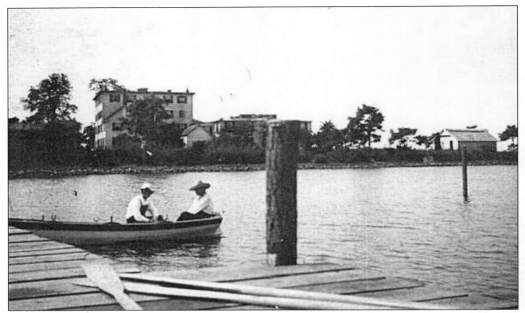

ROW BOAT. Anyone living near the water at least had a row boat that they used for fishing, crabbing, or just a leisurely ride. These men must have found it somewhat difficult to maneuver this boat, as the oars are shown still lying on the pier. They are not identified, but the lighthouse on Blackistone's Island can be seen in the background.

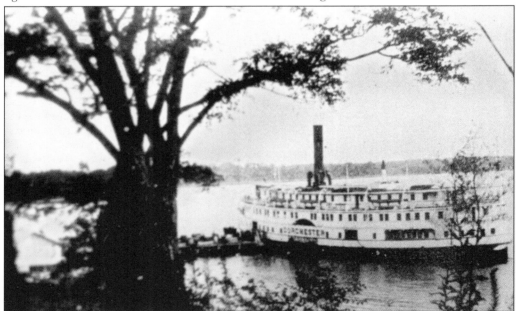

DORCHESTER STEAMBOAT. This was one of the many steamboats that provided services to county residents along the Potomac and Patuxent Rivers. They were used to transport passengers and freight to and from Washington, D.C., and Baltimore and all points in between. Regina Hammett tells us that in 1905 a round trip from Baltimore to one of the Potomac landings could be taken for $3.50. (Courtesy St. Mary's County Historical Society.)

THREE NOTCH ROAD, 1898. In 1696 the General Assembly passed legislation to mark roads throughout Maryland, stipulating that a "Road that leads to any County Court house shall have Two Notches on the Tree on both sides the Roades and another Notch a distance above the other two; any Roade that leads to a Church shall be marked at the Entrance into the same at leaving any other Roade with a Slip cut downe the face of the Tree near the ground; and any Roade leading to a Ferry and devideing from other Publick Roades shall be marked with Three Notches of Equall distance at the Entrance into the same." Today's Route 235 is what used to be called the "Three Notch Road." It begins just south of the village of Mechanicsville and continues on to Ridge along the eastern side of the county. It is hard to imagine that the road shown in this picture was once considered a major thoroughfare. (Courtesy Maryland State Archives.)

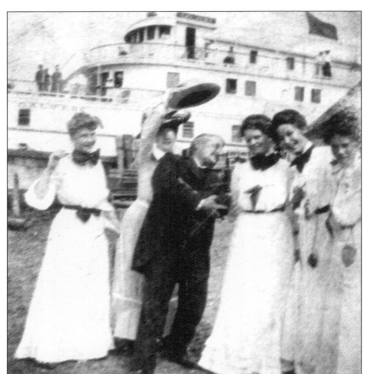

STUDENTS BESIDE STEAMBOAT. Mr. James Thomas Brome is pictured here in 1903 at Brome's Wharf with several students from St. Mary's Female Seminary. Brome's wife was Eliza Emeline Thomas, who also graduated from this school. Stella Boone (Class of 1905) is at the far left. Florence Mellor (Class of 1903) is on the far right. (Courtesy St. Mary's College of Maryland Archives.)

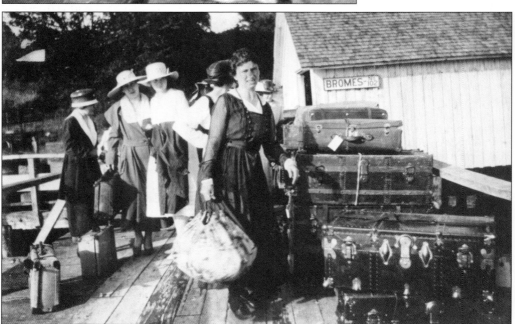

GOING HOME. This picture is not dated, but judging from the clothing styles it was undoubtedly the early 1900s. Here we see some of the students from St. Mary's Female Seminary, again at Brome's Wharf, with their trunks and valises packed and ready to be loaded on-board, probably to go home for the summer. (Courtesy St. Mary's College of Maryland.)

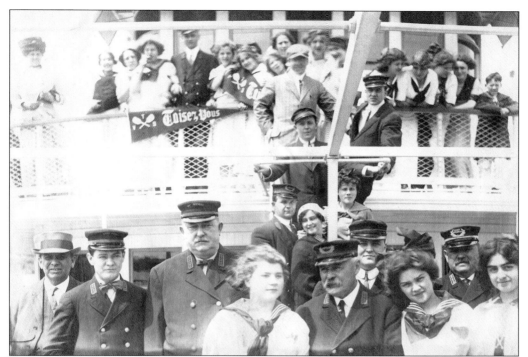

ALL ABOARD! This picture was taken in 1913 aboard the steamboat *Three Rivers* and shows the students from St. Mary's Female Seminary on an outing. The students in the foreground are Josephine Saunders, Alice Minnick, and Mary Costin. With them is Capt. Bill Geoghegan. (Courtesy St. Mary's College of Maryland Archives.)

LOADING SCHOONER. Shipping goods to market was not a simple task in the early days. The men had to first load the wagon, drive the horses to the wharf, load the goods into the boat, and then row out to the schooner to unload there. Do we really yearn for the good old days? (Courtesy Historic St. Mary's City Commission.)

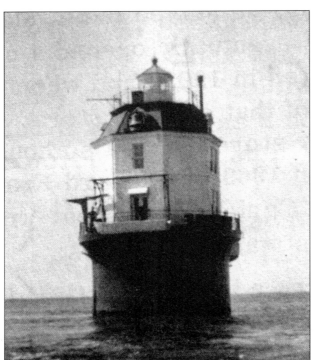

POINT NO POINT LIGHTHOUSE. This light is accessible only by boat and is located in the Chesapeake Bay about two miles off St. Jerome's Neck. Construction began in 1902 but was delayed twice because of heavy damage caused by gale-force winds in 1902 and an ice-storm in 1904. The lighthouse was finally finished in 1905.

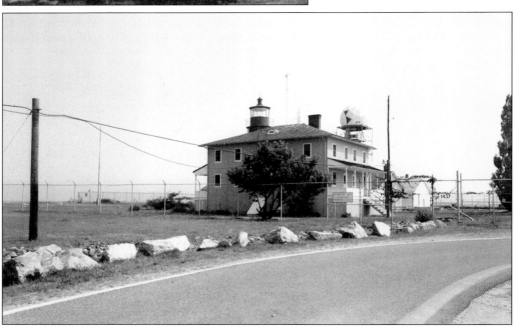

POINT LOOKOUT LIGHTHOUSE. This is the lighthouse as it appeared from 1883 onward. When it was built in 1830, there was only one story. James Davis, the first lighthouse keeper, was appointed in 1830 and died shortly thereafter. He was succeeded by his daughter, Ann, who served until 1847. The third keeper was William Wood, who married Susanna Heard, Ann's niece. The lighthouse is now owned by the U.S. Navy. (Courtesy Ralph Eshelman.)

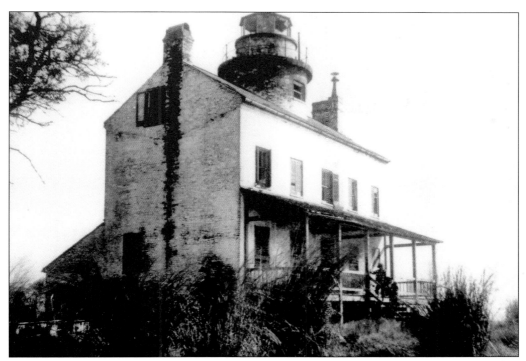

BLACKISTONE ISLAND LIGHTHOUSE. Established in 1851, this lighthouse was deactivated in 1932 and destroyed by fire in 1956. The first lighthouse keeper was Jerome McWilliams, who served from 1859 to 1875. In 1864 Confederate raiders put the light out of commission, but it was quickly repaired. For the duration of the war, the lighthouse remained under Union patrol and protection. (Courtesy St. Clement's Island Museum.)

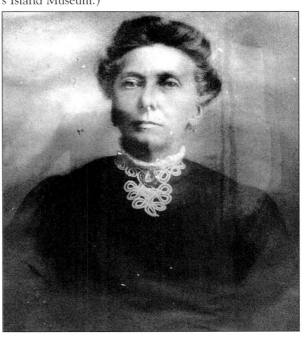

JOSEPHINE (MCWILLIAMS) FREEMAN. Mrs. Freeman served longer than anyone else as lighthouse keeper at Blackistone's Island. She took over from her brother Jerome McWilliams in 1875 and remained until her death in 1912. She was the daughter of Dr. Joseph McWilliams and Eliza Alvey. This picture is not dated, but it was probably taken in the early 1900s. (Courtesy St. Clement's Island Museum.)

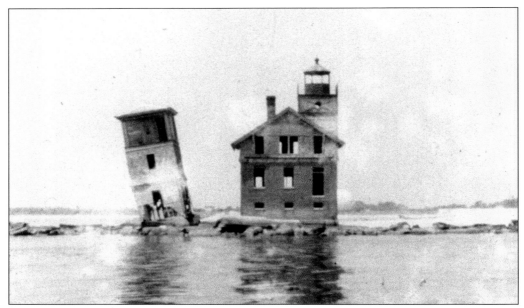

CEDAR POINT LIGHTHOUSE. This lighthouse was built in 1896 on a very small island now partially submerged. It contained a keeper's dwelling, two storerooms, and a square tower for supporting a lantern. There was also an oil house, a boathouse, and a small outhouse on site. The lighthouse was deactivated in 1928, and the upper portion was lifted by crane onto a barge and taken to the Calvert Marine Museum in 1996. (Courtesy St. Clement's Island Museum.)

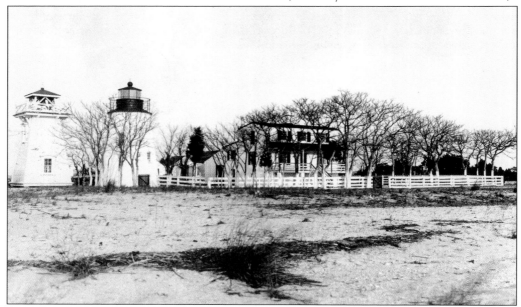

PINEY POINT LIGHTHOUSE. Built in 1836 at a cost of $5,000, the Piney Point Lighthouse and keeper's quarters are located on the Potomac River about 14 miles north of Chesapeake Bay. It was decommissioned in 1964. In 1980 the U.S. Coast Guard transferred ownership to St. Mary's County. It is now under the aegis of the St. Clement's Island–Potomac River Museum. (Courtesy St. Mary's County Historical Society.)

JEFFERSON ISLAND CLUB. Established in 1930 as a hunt club by the Democratic National Committee, the Jefferson Island Club was originally located on an island in the Chesapeake Bay. When the clubhouse burned in 1946, the club was relocated to St. Catherine's Island in St. Mary's County, and a new club house was built. This photo, taken in the early 1960s, shows President Truman at a party there. Presidents Kennedy and Johnson were also frequent visitors. (Courtesy Kenny and Kathy Robeson.)

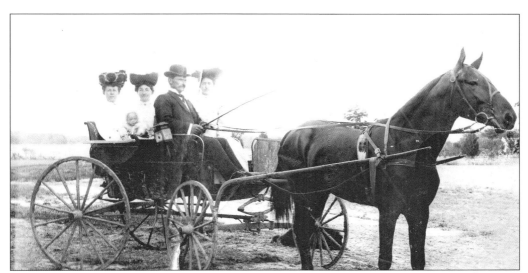

HORSE AND BUGGY. This picture was found among those of the William Fitzhugh Chesley family of Charlotte Hall and was probably taken about 1894 while the family was on their way to church or perhaps out for a leisurely Sunday afternoon drive. This was fine for days when it was warm and sunny, but it must have been most unpleasant when the weather was cold and wet. (Courtesy Patti and Bill Poffenbarger.)

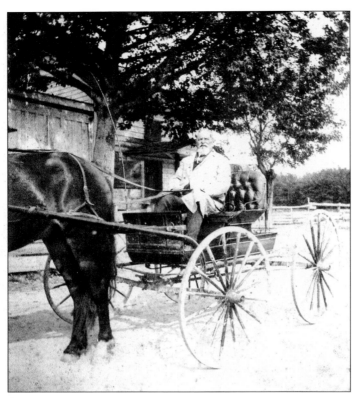

HOUSE CALL. This is Dr. James Henry Miles (1821–1907) at his home, Bluestone Farm, at St. Mary's City. When this picture was taken, he was probably on his way to treat one of his patients. Dr. Miles graduated from the University of Maryland in 1845 and began practicing in Great Mills. His private practice was interrupted for several years when he was drafted by the Union Army in 1862. (Courtesy Historic St. Mary's City Commission.)

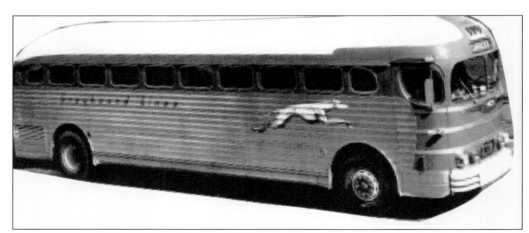

ATWOOD AND GREYHOUND BUSES. St. Mary's County was served by both Atwood and Greyhound bus companies. This 1940s-era photo brings back many happy memories of trips to Washington, D.C., to shop or visit city cousins. You did not need to worry about being at a bus terminal; all you had to do was to wave your arm high in the air as the bus approached and the driver would stop and pick you up.

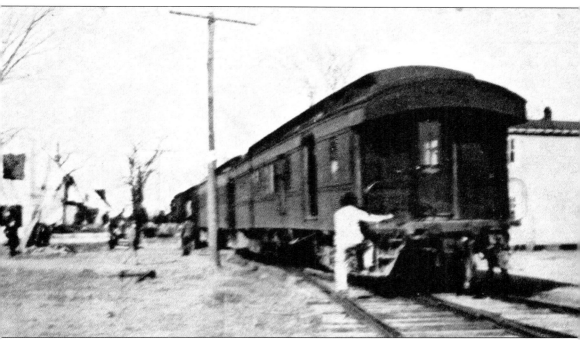

RAILROAD STATION AT CHARLOTTE HALL. Original planning called for trains to run from Point Lookout to Washington, D.C., but those plans never fully materialized. By 1870, however, there was train service from Brandywine to Mechanicsville. Four different companies owned the railroad between 1868 and 1917, none of them making any substantial progress. In 1917 the railroad was sold to a junk dealer for scrap metal. He immediately began pulling up track. William Bernard Duke assisted local farmers in successfully filing an injunction to stop destruction of the track; they acquired it and created a company. From that time forward, it was locally owned and operated and referred to as the Farmers' Railroad. In 1924 William F. Chesley Jr. was appointed as general manager. This train ran only two days per week so that the employees, who received minimal pay, could work on their farms to supplement their income. Locals often volunteered to serve on train days as station agents to help save money. This undated postcard refers to a station there, but this was most likely Mr. Chesley's house. (Courtesy Lois Duke.)

TRUCK TRAIN. Yes, it's true. This truck, converted to a train, was purchased from a four-wheel drive factory in Wisconsin in the 1930s, loaded onto another train, and brought to St. Mary's County, where it remained in service for many years thereafter. It was not very attractive, but it got the job done. (Courtesy Jim and Marie Chesley.)

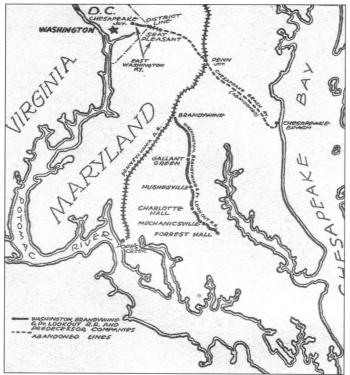

MAP OF TRAIN STOPS. Although faster than horseback and slightly more comfortable, by the time the train made its way down the countryside, making all of the stops and waiting while goods were loaded and unloaded, travelers must have been very weary when they finally reached their destination. Even on downhill grades, the train rarely traveled faster than a breakneck speed of 25 miles per hour.

RAILROAD PASS, 1876. Ignatius Enders Mattingly was born in Bushwood in 1845. At the time this pass was issued, he would have been on his way to Annapolis where he would be sworn in as St. Mary's County's representative to the Maryland House of Delegates on January 5, 1876. The family undoubtedly kept this as a treasured memento. (Courtesy St. Clement's Island Museum.)

WILLIAM F. CHESLEY. It is impossible to mention railroads in St. Mary's County without mentioning Mr. Chesley. His love affair with trains began in 1906 when he was a telegraph operator on the Kansas City Southern. In 1924 he became general manager of the Farmers' Railroad. When the U.S. Navy took over in 1942, he began working for them and was still there in 1954 when railroad operations ceased entirely. (Courtesy Jim Chesley.)

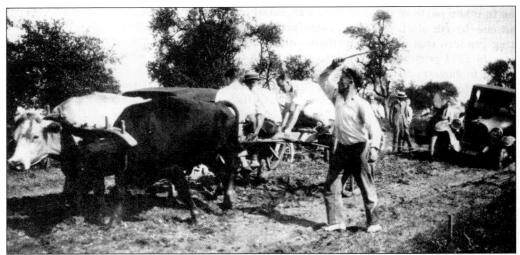

EARLY AUTOMOBILES. This picture, taken about 1920, is just one of those that "says it all." Here we have a team of oxen pulling one those new contraptions out of the mud where it had been mired near Colton's Point. When the cars could move, the speed limit in some places was 12 miles per hour and local citizens felt even that was much too fast. (Courtesy Carl Kopel.)

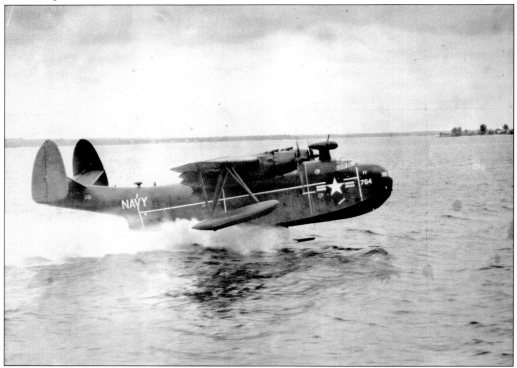

AIRPLANES. Prior to World War II and the arrival of the U.S. Navy in 1942, residents rarely saw a plane. Suddenly the sky was filled with planes of all kinds, with some even landing on the water, as shown here. In 1958 the United States Naval Test Pilot School was established here where four of the original seven astronauts graduated, including Alan Shepard, the first American in space.

Six
FAMILIES

When the colonists came to Maryland, there were very few intact families among the group. Most of the immigrants were indentured servants and most were men. There were very few women. As a result, widows remarried in short order, often before their deceased husband's estates were administered. Occasionally widows married men who were former servants. Hugh Lee died in 1662, and his widow Hannah married William Price, a former servant, shortly thereafter.

Perhaps the lack of family in the early days accounts for the fact that as time went by, families clung together and stayed together. When people began migrating to other states and to nearby cities, they did not go alone but in familial groups. Once they arrived, they remained together, settling in the same area.

When asked where we are from, most natives do not respond by saying Ridge, Chaptico, or Mechanicsville; we say St. Mary's County. Some would be surprised how often people know exactly where that is. Once at a business meeting in Denver, Colorado, the author proposed that the next meeting be held in St. Mary's County. Afterwards, on the way back to the hotel, a colleague was in a taxi with a lady from Kansas City who was railing on, saying, "what's the big deal about St. Mary's County. Who ever heard of it?" The taxi driver spoke up and said, "I've heard of it, my grandparents were born there."

LOVE CHILDREN. This c. 1915 picture shows, from left to right, Benedict, Philip D., and Eleanor Love, children of Benedict Love and Annie Graves. Eleanor was angry when the picture was taken because she wanted to be on the bicycle. She refused to hold the flowers and was only partly consoled by being allowed to hold her wooden horse. Look a little closer and you will note that her shoes were on the wrong feet. (Courtesy Betty Peterson.)

GEORGE D.C. DICKERSON. Born into slavery in 1862, George (and his parents) were the property of Mrs. Emeline McWilliams. He, his mother Eleanor, and siblings Harriett, William, and Emily were emancipated by the State of Maryland on November 1, 1864. His father, John Dickerson (1834–1901), had earlier escaped the bonds of slavery when he enlisted in the Union Army. Few people are aware that the Emancipation Proclamation issued by President Lincoln on September 22, 1862, did not actually free any slaves. It applied only to the states that had seceded from the Union over which he had no real control at the time, and it had no bearing in any of the other states, Maryland among them. When John Dickerson died in 1901, he owned 200 acres of land, part of which is on the Potomac River and within sight of St. Clement's Island. An equity court case soon followed to provide for a division of the property among his heirs. Part of this property is still in the possession of his descendants. (Courtesy Purnell and Rita Dickerson Frederick.)

HELEN HAYES. Helen Hayes, "The First Lady of the American Theater," often visited her father, Frank Brown, until his death in 1940 at his home here on the Chesapeake Bay. Mr. Brown is said to have been the last person buried at St. Nicholas Church before the navy took over the property in 1942. Helen is shown here on the beach, prior to 1940, with some of the neighborhood children. (Courtesy St. Mary's County Historical Society.)

ELLIS FAMILY. Shown here about 1914 is Rose Etta (Mattingly) Ellis, the wife of John Sheehan Ellis and her sons, from left to right, Arthur, Andrew (on her lap), and Irving. The family later moved to Washington, D.C. Rosie died in 1931, and John died in 1936. Like many other St. Mary's Countians, they were brought back home for burial and now rest at Sacred Heart Church in Bushwood. (Courtesy Joann Ellis Humphries.)

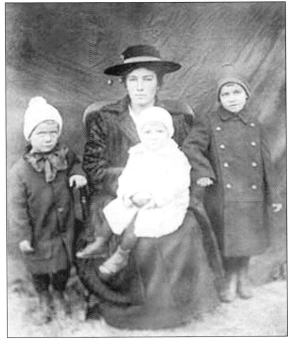

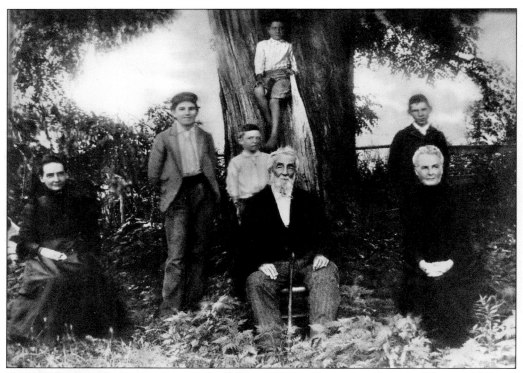

COAD FAMILY AT LOCUST VIEW. This picture is dated July 10, 1892, and was taken "by a couple of scholastics from the Villa at St. Inigoes who rowed over to Cherryfields and walked with the four boys over to Locust Grove." Shown from left to right are Maggie Combs, Robert E. Lee Allan, William T.B. Coad, Lewis Cornelius Combs, Cecelia (Coad) Roberts, and George A. Allan. J. Allan Coad is sitting in the old locust tree. (Courtesy Historic St. Mary's City Commission.)

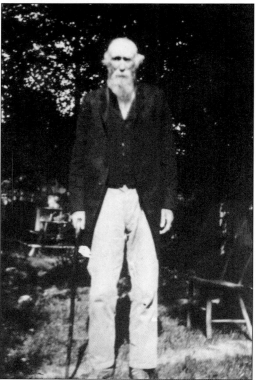

HAYDEN MARTIN HENRY YATES. Mr. Yates (1838–1914) was a teacher and farmer. Married twice, he was the father of 11 children. A descendant of Martin Yates, he was born in 1666 in England and transported as an indentured servant prior to 1685. Martin Yates, like many others who came to Maryland under the same circumstances, worked hard, and by 1707 he owned 148 acres called "Turvey." He was an innkeeper when he died in 1724. (Courtesy Historic St. Mary's City Commission.)

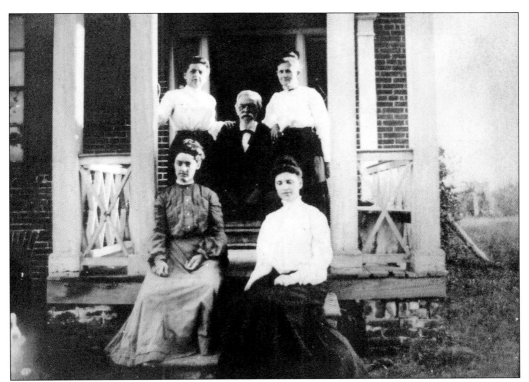

MILES FAMILY. This photo was taken prior to 1907 at "an old house at St. Inigoes." Pictured here is Flora (Bean) Miles, Dr. James Henry Miles, Susan (Rollins), Mamie McCauley, and Mary (Rollins) Britton. The Rollins girls were Flora's first cousins and lived in Baltimore. Their mother was Rosalie Bennett, and Flora's mother was Jane Lucretia Bennett, daughters of John White Bennett and Elizabeth Loker. (Courtesy Historic St. Mary's City Commission.)

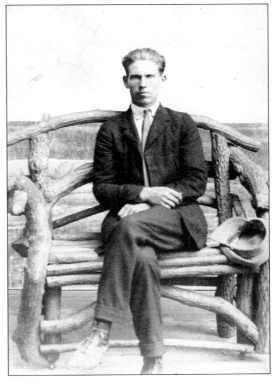

WILLIAM GORMAN DAVIS. Gorman Davis was of age by the Roaring Twenties. He was one of the hundreds of local men who made moonshine whiskey during Prohibition. After two terms of a year and a day each as a guest of the feds, he had had enough and moved to Baltimore, where he employed his real trade as an automobile mechanic. He died in 1971 at the age of 70.

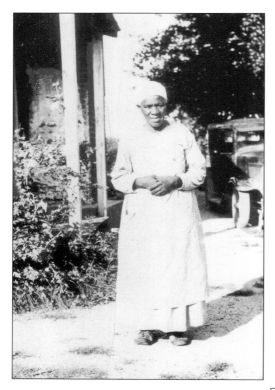

AUNT MAYA. Members of the Graves family came from far and wide to "Bachelor's Rest" this day in 1935 to celebrate the birthday of their beloved Aunt Maya. She had lived with and had been considered a part of the family since at least 1870. Born in 1855 into a slave family, her real name was Mary Louisa Mills. (Courtesy Betty Peterson.)

FORD GRAVES POSTCARD. Lewis Ford Graves (1847–1935) was the son of Lewis Rudolph Graves and Ann Ford. In 1875 he married Ellen L. Jarboe, a direct descendant of Lt. Col. John Jarboe. Lieutenant Colonel Jarboe was a soldier born 1619 in Dijon, France, who was living in Kecoughton, Virginia, in 1646 when Leonard Calvert organized the expedition to recapture Maryland after Richard Ingles had seized control. (Courtesy Betty Peterson.)

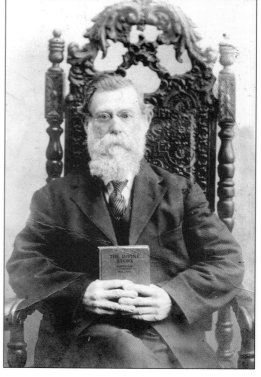

REBECCA ANN MILLARD. Born in 1806 in St. Mary's County, in 1836 Rebecca Millard married Forbes Britton, a young lieutenant and graduate of West Point who spent most of his army career moving Native Americans from the Southeast to sites in "Indian Territory." In 1850 the family settled in Corpus Christi, Texas. Captain Britton was later elected to the Texas legislature and was commissioned as chief of staff to General Houston with the rank of brigadier general. (Courtesy St. Mary's County Historical Society.)

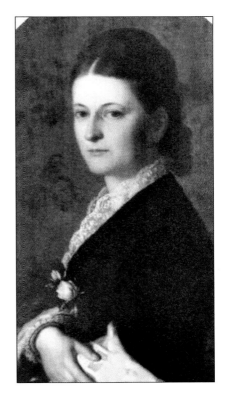

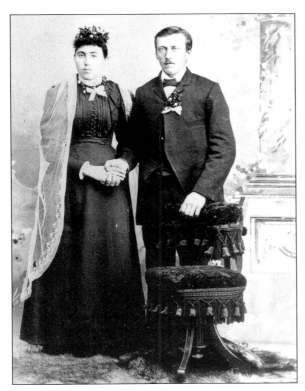

MUELLER WEDDING PICTURE. This wedding portrait was made about 1894 in Smith County, Kansas. Pictured are Heinrich Mueller, who landed at Ellis Island, and Elfriede Carstens; both were German immigrants. Elfriede worked as a housekeeper for a year, at a dollar a week, to pay for her wedding dress. The Muellers, along with several other German families, moved from Kansas to the New Market area about 1910 and were the founders of St. Paul's Lutheran Church. (Courtesy Don Mueller.)

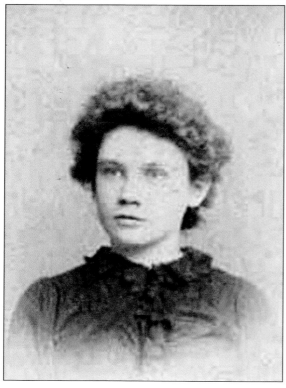

AMISH AND MENNONITE COMMUNITIES. Members of both groups moved here from Lancaster County, Pennsylvania, beginning in 1939. The Amish live in the New Market area, while the Mennonites live in the Loveville and Oakville area. Both groups shun modern ways. They are good farmers and good neighbors. Horse-drawn buggies are seen throughout the area, and local grocery stores provide hitching posts.

FLORA LOVE JOHNSON. Born in 1873, Flora Johnson was the eldest daughter of Dr. Samuel Love and Charlotte Chunn. Flora died under mysterious circumstances and it was alleged that she had been murdered by her husband. A coroner's inquest was held with several jurymen saying she died "in a natural way by visitation of God while others said she was killed by Peter Johnson by being struck which caused internal hemorrhage." (Courtesy Bill Johnson.)

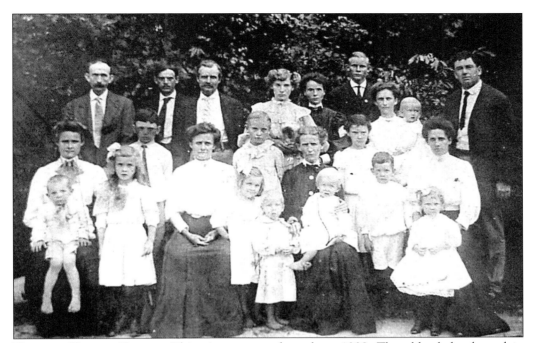

HARDING/GRAVES FAMILY. This picture was taken about 1908. The older lady, dressed in black, was Permelia Harrison Graves (1850–1927), widow of Joseph Rowen Harding, who died in 1884. Permelia was a descendant of John Graves (1665–1748) and his wife, Ann. She is surrounded by her daughters, sons-in-law, grandchildren, nieces, and nephews. This family lived in the Laurel Grove/Oakville area. (Courtesy Marjorie Leinfelder.)

JAMES JOY (1815–1871). Mr. Joy was born Catholic, but in 1851 at the age of 36, he converted to the Methodist faith. In 1868 he gave land from his farm "for use as a place of divine worship." Joy Chapel, named in his honor, was built the same year. He was married three times, but all of his children were by his first wife, Ann "Nancy" Wise, who died in 1845. (Courtesy Judy Dean Wood.)

CHARLES MCKENNY GRAY FAMILY. Mr. Gray was born on August 22, 1867, and died on February 29, 1940. He married Lucinda Ann Pilkerton (August 2, 1873–July 4, 1953) on September 9, 1889. Everyone was dressed in their Sunday best when this family picture was taken about 1919. From left to right are Charles Sr., Lucinda, Katherine, Charles Jr., Martin, Albert, Frederick, and Anna Gray. (Courtesy Charles Gray.)

TYLER CHILDREN. David Bruce Tyler and his wife, Lucy, were living at this house called "Fenwick Free" and located in St. Inigoes when this picture of their children and a niece was taken in 1916. By the time of the 1920 census, the family was living in Philadelphia. Mr. Tyler was the great-grandson of Thomas Lynch, a private in the Maryland Line who participated in the Battle of Long Island on August 27, 1776. (Courtesy Scott Lawrence.)

ANN CLARISSA (MARTIN) BEAN. Ann was born in 1815. In 1851, at the ripe old age of 36, she married John Henry Bean of Piney Point, who had been widowed twice before. Mr. Bean died of dropsy in 1859, owning 250 acres "on the Potomac River, a wharf immediately in the neighborhood which steamboats ply to and from." (Courtesy Scott Lawrence.)

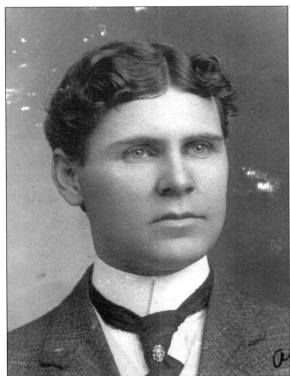

ZACHARIAH DEMINIEU BLACKISTONE JR. Zachariah Deminieu Blackistone Jr. was born at River Springs on February 16, 1871. As a young man he moved to Washington, D.C., and in 1898, with his last $10 and a meager stock of flowers obtained by loans from friends, he founded Blackistone's Florist. By 1959 he owned five stores and was the primary source of floral arrangements for the White House. Mr. Blackistone died on April 18, 1982, at the age of 111. (Courtesy Dave Cummins.)

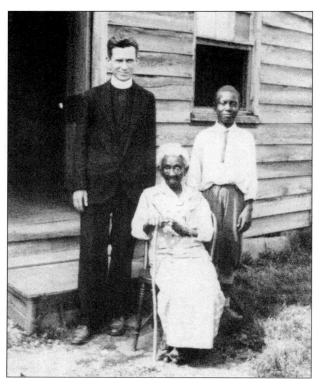

AUNT PIGEON. When Eloise Young of Prince George's County married George Smith in 1841, she came to live at Smithwood in St. Mary's County, bringing with her a slave named Mary Ellen Whalen, later known as Aunt Pigeon. After George Smith's death, the family faced serious financial problems, and Aunt Pigeon was sold to Eloise's half-sister, Julia Fidelas Young, wife of Henry Clay Clarke. Aunt Pigeon died in 1937 at age 108. (Courtesy Father Damian Shadwell.)

HAMMETT CHILDREN, 1909. Pictured here are the four eldest children of George David Hammett and Minnie Beatrice Watts. From left to right are Dorothy, Gibbons, Mary, and George. They were the descendants of Robert Hammett (died 1719) and Catherine Lawrence, the progenitors of the Hammett family in St. Mary's County. Through their mother, their roots go back even further to William Watts, who was here prior to 1670 and died in 1685. (Courtesy Scott Lawrence.)

ALEXANDER BEAL AND FAMILY. This picture, taken about 1887, shows Alexander Beal, his wife, Lucy Dunbar, and their daughters, Myrtle Etienne and Marie (the baby). Mr. Beal was born near Tall Timbers. He served in Company B of the Maryland Calvary, CSA. Captured at Gettysburg, he was imprisoned first at Fort Delaware and then at Point Lookout Prison. During his civilian life, he was a purser on the steamers out of Baltimore. (Courtesy Heather Ostrom.)

EDWARDS FAMILY. Thomas Columbus Edwards (1845–1941) and his wife, Mary Frances Lloyd (1846–1922), are shown in this family portrait taken about 1905. They are seated together in the third row to the right. The Edwards were farmers and lived at Suttle's Range near Chaptico. Mr. Edwards often said that this property had been in his family for five generations. Suttle's Range, containing 370 acres, was surveyed in 1680 for John Suttle. (Courtesy Jean Edwards.)

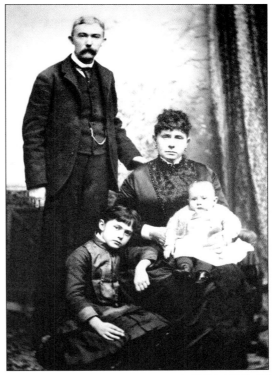

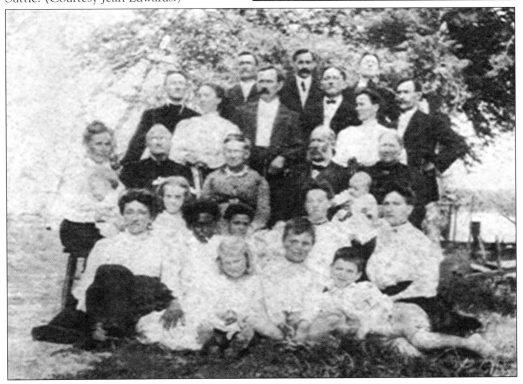

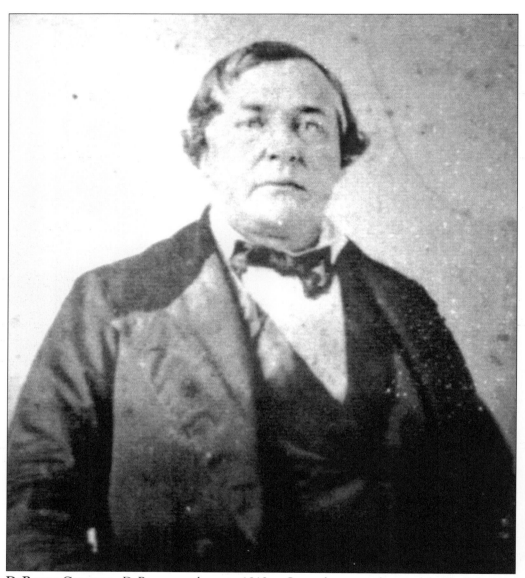

DeRosey Carroll. DeRosey was born in 1813 at Susquehanna and named for Fr. Sebastian DeRosey, pastor at St. Nicholas Church. Carroll's family fled to Prince George's County early in 1815 after suffering repeated British raids on their property. Upon reaching adulthood, DeRosey moved to Mississippi, Alabama, and finally to Arkansas. At the outbreak of the Civil War, he was commissioned as a colonel in the CSA. Arkansas was a divided state and occupied by both armies, and they adhered to the rules and regulations of war, but by 1863 the area was overrun with bushwackers, jayhawkers, and guerillas. One of these was Capt. Martin Hart. Although a loyal Union man, he sought and received a commission with the Confederacy to enable him to cross their battle lines. On January 14, 1863, Captain Hart and his renegades began raiding homes to kill known Confederates. Their third stop and second murder was DeRosey Carroll. Captain Hart and his troops were soon captured by Confederate forces. A court martial was convened, and Hart, along with Lt. J.W. Hays, was found guilty and hanged. (Courtesy Helen Carroll Beavers Patterson.)

WILLIAM LAWRENCE WATHEN. Mr. Wathen was born in 1863. He was a farmer who, like so many others, lived quietly, worked hard, raised a family, and was true to his church and his values. He was one of the many descendants of John Wathen and Ann Hudson, progenitors of the Wathen family in Southern Maryland. His wife, Missouri Morgan, was a descendant of Edward Morgan, who was transported prior to 1675. (Courtesy Phyllis Superior.)

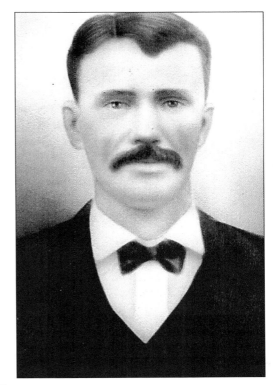

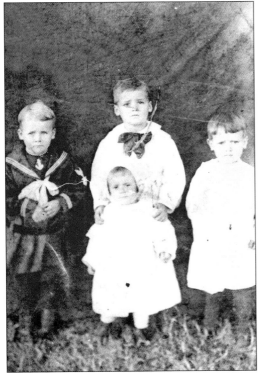

GASS SIBLINGS. This picture, taken about 1917, shows the children of Joseph Carroll Gass and Ella Mae Cullins. The boys, from left to right, are Frank, Cullins, and Herman. The baby standing in front is Mary Jane. Joseph Carroll Gass was a life-long waterman and was called "Captain Sally." The family lived at Colton's Point. (Courtesy Juanita Gass.)

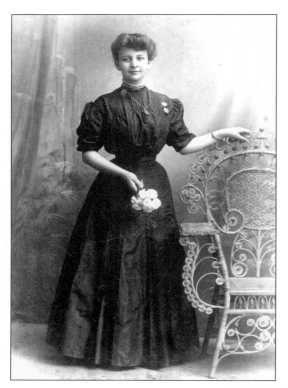

NOEMA (WATHEN) ABELL. Born in 1886, Noema lived to the age of 100. She was one of the seven graduates of St. Mary's Academy in 1904 and is shown in this portrait proudly displaying the mathematics medal she received for excellence in that subject. After graduation she taught school at Newtown until her marriage in 1910 to John Fulton Abell. She also served as postmistress of the Compton Post Office from 1936 to 1957. (Courtesy Heather Ostrom.)

HATCH AND GILBERT DENT. These beautiful little boys were first cousins through their mothers and were both born on August 15, 1905. On the left is Theodore Hatch Dent, son of Walter Benjamin Dent and Eleanor Grace Blackistone. To his right is Wade Gilbert Dent Jr., son of Wade Gilbert Dent and Martha Lucinda Hebb Blackistone. This picture was taken about 1910. (Courtesy David Cummins.)

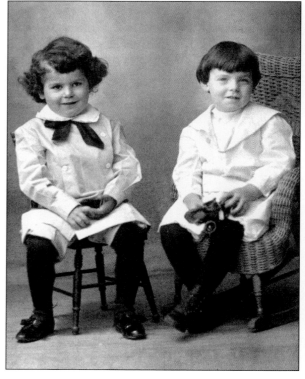

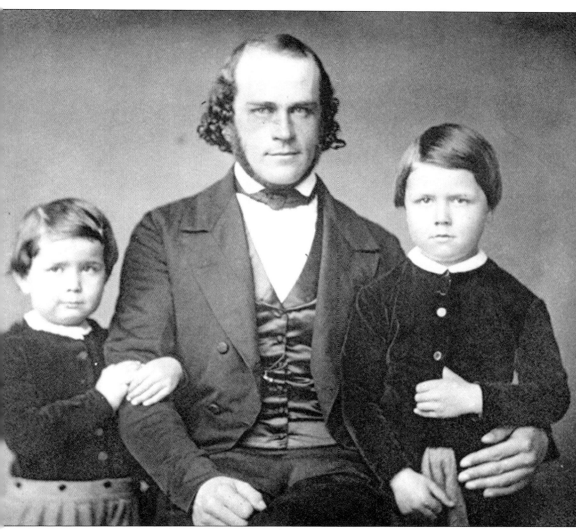

JAMES ATHANASIUS FENWICK AND CHILDREN. The son of Col. Athanasius Fenwick and Susan Howell, James Fenwick was born in St. Mary's County at Cherryfields in 1818. After his parents died in 1824, he and his sisters were raised by their Howell relatives in Philadelphia. Fenwick later acquired property in New Jersey, naming it Fenwick Manor, where he was a successful farmer and grower of cranberries. His sisters, Margaret and Susan, neither of whom married, lived there as well. In 1869 his daughter Mary Anne married Joseph Josiah White, and they also lived at Fenwick Manor. Mr. White would later become a founding father of what would become the Ocean Spray Cranberry cooperative. Their daughter Elizabeth White introduced the nation's first cultivated blueberry. While the manor house is used as the administrative offices of the New Jersey Pinelands Commission, the surrounding property has been retained by Mr. Fenwick's descendants. Katherine Darlington Thompson, a great-granddaughter, is the owner and manager of Fenwick Manor Farm. This 1850 picture shows James Athanasius Fenwick with his children—Mary Anne, born in 1847, and Fenwick's namesake, called Thane, born in 1844. (Courtesy Thomas B. Darlington.)

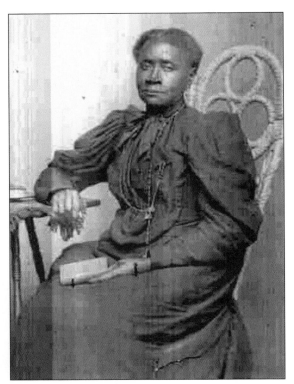

Phyllis (Lansdale) Clarke. Born about 1855, Phyllis was probably the daughter of Frank Lansdale (born 1806) and his wife, Margaret (born 1815), who in 1880 were living in Leonardtown near Phyllis and her husband, Marydach Clarke. By the time of the 1900 census, Phyllis was widowed and living with her son, Joseph Clarke. This picture of her was taken between 1890 and 1900. (Courtesy St. Mary's County Historical Society.)

Helen Marguerite Dent. In earlier days, illnesses that we consider now of little or no consequence were often killers. Helen, a student at St. Mary's Female Seminary, was stricken with appendicitis. Even her father, a physician, could not help her, and she was taken to George Washington University in Washington, D.C., by a U.S. Revenue Cutter. By then it was too late. She died at the age of 18 on January 22, 1913. (Courtesy St. Mary's College of Maryland Archives.)

JAMES WILLIAM THOMAS. Although he is not shown in uniform, Jim Thomas served as a first sergeant in Company A of the 2nd Maryland Regiment during the Civil War. In 1871 he married Fantelina Shaw of Shaw's Retreat near Charlotte Hall, and after their marriage, they lived there. His brother, Richard ("Zarvona") died at his home in 1875. When his next son was born in 1876, Jim Thomas named him Richard Zarvona Thomas.

MICHAEL AND SUSAN MCGUIGAN. Born in Pennsylvania in 1887, Michael McGuigan was one of many orphans from Northern states taken in by families from St. Mary's County during this era. At the time of the 1900 census, he was listed as the adopted son of Mary (Davis) Floyd. This picture was probably taken on the day of his marriage in 1907 to Susan Rebecca Adams, the daughter of Joseph Adams and Catherine Dean. (Courtesy Don Mueller.)

ANDREW M. GARNER. Mr. Garner was born in 1834 and died in 1903. He was a carpenter by trade and lived in the Hollywood area. His wife was Sarah Catherine Abell. Among his many St. Mary's County ancestors was Dr. Luke Barber, who immigrated to Maryland in 1654 aboard the *Golden Fleece* and was granted 1,000 acres of land in Chaptico Hundred for his service at the Battle of the Severn. (Courtesy Lois Duke.)

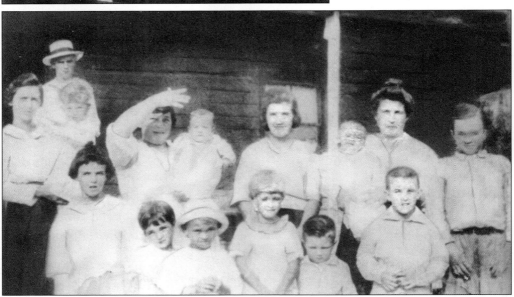

MARY MYRTLE (RUSSELL) MORGAN AND FAMILY. Called "Myrtie," Mary Morgan was born around Chaptico in 1888 and was the wife of John Woodley Morgan. The family owned a farm near Oraville for many years before moving to the Helen area. This picture was taken about 1920. Myrtie is in the back row to the far right. In all, she had 14 children, of whom 5 would not live to adulthood; neither figure is unusual for that era.

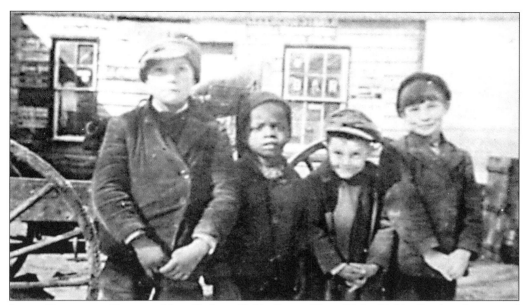

LOVE BOYS AND FRIEND. Identified as Philip Love, Tom Dish, Philip Dunbar Love, and Benedict Love, this picture was taken about 1910. One can only imagine how much mischief these four must have caused around the farm. Store-bought toys were rare, and children made do with what they had. It was an innocent time when children were still allowed to be just that. (Courtesy Betty Peterson.)

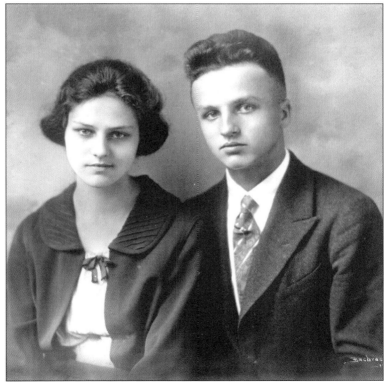

FRANCIS DUKE AND GRACE ANGELA DUKE. This picture, taken in the early 1920s, is of the attractive children of Benjamin Hooper Duke and Grace Aileen Dent. Francis never married and died in 1949 at the young age of 45. He was a veteran of World War II. Grace became a nun and was known as Sister Benedicta. (Courtesy Lois Duke.)

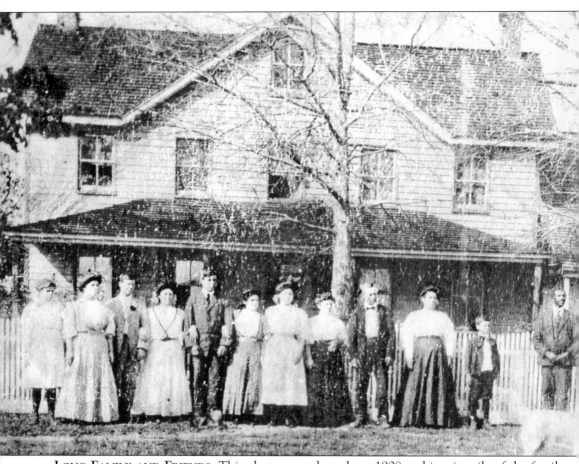

LONG FAMILY AND FRIENDS. This photo was taken about 1908 and is primarily of the family of John Robert Long and his wife, Nancy Johnson, who were married in 1885. The Long family lived on Bishop Road, located between Loveville and Oakville. Pictured from left to right are Anna Mae Long (married to John W. Wathen); Madeline Long; Francis Irvin Long (married to Eunice Knott); Alberta Marie "Vertie" Long (married to John Franklin Bailey); Joseph Albert Long (married to Mildred Marshall); Mary Genevieve Mattingly (married to Ignatius Truman Wathen); Lillian Florrine Long (married first to Wilbur Tippett and second to Louis Spencer Abell); Mary Elizabeth Johnson, wife of John Jacob Hess; John Robert Long Sr.; Nancy C. "Nanny" (Johnson) Long; John Robert Long Jr. (married to Alma Leach); and Moses Jenkins. Missing from this picture is daughter Lucy Estelle "Stella" Long, who married James Warren Guy. John Robert Long was the son of William Henry Long and Sarah Maria Bennett. Nancy C. Johnson was the daughter of Hilary Edward Johnson and Ann Maria Thompson. (Courtesy Lois Duke.)

Seven
WAR AND PEACE

From 1635 until today, St. Mary's Countians have fought and died both here and abroad as the need has arisen. The names of the men and the conflicts in which they served would consume an entire book, so we will only mention a few from earlier times.

To William Ashmore, who in 1635 was the first man to lose his life while defending St. Mary's from William Claiborne, we thank you. To John Jarboe and William Evans, we lend our appreciation for having recaptured the fledgling Maryland colony from the likes of Richard Ingle in 1645. To William Eltonhead, William Lewis, and Thomas Hatton, who were executed after the Battle of the Severn in 1655 despite promises from the Puritans to the contrary, your lives were not lost in vain.

To Thomas Truman, who commanded the Maryland Militia in 1673, when Maryland and Virginia made a joint attack against the Susquehanna Indians, we applaud your mercy and detest those who tried to bring dishonor to your name. To William Claw, who was "slain before the Susquehanna Fort" in 1675, your sacrifice is appreciated. And to the Maryland 400 who saved America's army at the Battle of Brooklyn Heights while fighting against massive forces, we will never forget. General Washington said of you, "Good God, what brave men must I lose this day!" For the privilege of being called U.S. citizens and for every freedom we enjoy, we humbly thank you.

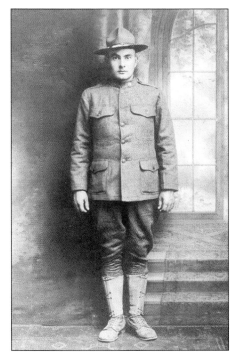

LOUIS SPENCER ABELL. The son of Robert Alexander Abell and Susan Rebecca Garner, Louis Abell was born and raised in the Hollywood area. He was inducted into the army on July 24, 1918, and served as a private in Company L of the 71st Infantry. He was honorably discharged on January 24, 1919. In 1924 Abell married Lillian Florrine (Long) Tippett, a widow with two young children. (Courtesy Lois Duke.)

MICHAEL BROWN CARROLL. Michael Brown Carroll was born at Susquehanna in 1768. In 1798 he was appointed as a midshipman in the U.S. Navy. Almost immediately after his enlistment, he saw action in the Quasi War with France. He was promoted to lieutenant in 1802, and by 1803 he was in the Mediterranean serving in the Barbary Coast Wars. While there, he was one of the volunteers who took part in the successful mission to destroy the frigate *Philadelphia* after she was accidentally run aground while pursuing a Tripolitan war vessel. He also fought in the Battle of Tripoli. Upon his return to the United States, he served a short time at the Norfolk Naval Yard, and prior to February 3, 1812, he was assigned to the New Orleans Naval Station, just in time for the War of 1812 and the Battle of New Orleans. In 1815 he was promoted again, this time to master commandant. In 1817 Commander Carroll married Mary Ann King of Somerset County. In 1822 he resigned from the navy and returned to Susquehanna, where he died in 1831. (Courtesy St. Mary's County Historical Society.)

OFFICER MUSTER LIST. This undated original dates from the War of 1812 and is said to be a list of the officers in St. Mary's County. It appears to be the men from the 45th Regiment. The 45th Regiment was composed of men from the upper end of the county, while the 12th Regiment were those from the lower end. (Courtesy St. Clement's Island Museum.)

WILLIAM THOMAS "BILL TOM" BAILEY. Private Bailey enlisted with Company A of the 2nd Maryland Infantry at Richmond on August 25, 1862, for a period of three years or until war's end. On October 1, 1864, he suffered the loss of his left eye from cannon fire at the battle of Squirrel Level Road just outside Petersburg, Virginia. After the war Bailey returned to St. Mary's County, where he taught school. (Courtesy Rob Long.)

OATH OF ALLEGIANCE.

I, William Blair of St. Mary's County, Maryland, do solemnly swear that I will bear true faith, allegiance, and loyalty to the Government of the United States, that I will support and defend its constitution, laws, and supremacy against all enemies, whether domestic or foreign; any ordinance, resolution or law of any State Convention or Legislature to the contrary notwithstanding. Further, that I will not in any wise give aid or comfort to, or hold communication with any enemy of the Government, or any person who sustains or supports the so-called Confederate States; but will abstain from all business, dealing, or communication with such persons. And I do this freely, without any mental reservation or evasion whatsoever, with full purpose and resolution to observe the same; I also fully acknowledge the right of the Government to require this oath, the authority of the officer to administer it, and its binding force on me.

Subscribed and sworn to before me at Chaptico this 13 day of May 1865

Wm Blair

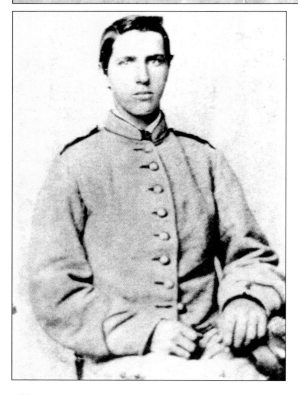

OATH OF ALLEGIANCE. When William Blair signed this document in 1865, he was 74 years old. At this age, it is highly unlikely that he had been a soldier or a member of the militia, so presumably he was an acknowledged Southern sympathizer or possibly a blockade runner. Blair, born in 1791, also served during the War of 1812. He was married twice, the first time at age 50. (Courtesy St. Clement's Island Museum.)

JOHN ALEXANDER HAYDEN. As did many others, John Hayden fled to Richmond and enlisted in the Confederate Army, serving in Company B, 2nd Maryland Infantry. John was wounded at the Battle of Culp's Hill at Gettysburg, Pennsylvania, on July 3, 1863, and died four days later. Henry Ford, another county boy, was also injured there but survived and was one of only nine soldiers left from Company B when they arrived at Appomattox Courthouse. (Courtesy Dave Mark.)

[Saint Mary's County ss.
...day of June 1812 — 3 personally appeared James
... Jarboe, Captain, named in
... Commission, before me one of the Justices of the peace
... State of Maryland, and in and for the County aforesaid
... doth solemnly swear, that he doth not bear allegiance
... King of Great Britain, nor any other King, Prince,
Potentate, or State whatsoever, except that he doth bear
... and faithful allegiance to the State of Maryland
... to the United States of America; — and that he
... diligently and faithfully do and perform the duties
... assigned to him as Captain of the Militia of the
... State of Maryland, according to the best of his skill
... abilities. —

Certified by J. O. Mackall Jr.

COMMISSION OF JAMES JARBOE. James Jarboe was the son of Robert Jarboe and Elizabeth Holton. Robert Jarboe served as an ensign during the Revolutionary War. James, following in his father's footsteps, also served his country. This is a copy of his commission as captain during the War of 1812. By the time of his death in 1845, he had attained the rank of colonel. The tombstone of Colonel Jarboe was one of the first recently excavated at St. Nicholas Church, now the Base Chapel at the Patuxent Naval Air Station. Inscribed on the stone is, "Pray for the soul of Col. Jarboe, died 1846." The tombstone is in error as he died in 1845. We can only assume it was placed long after his death. The town where Colonel Jarboe lived was called Jarboesville. The name was changed in the 1940s to Lexington Park. (Courtesy Randy Dunavan.)

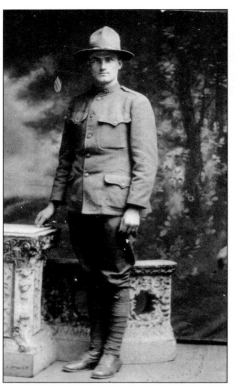

LOUIS POPE HEARD. This postcard shows Private Heard as a soldier during World War I. He died at the Base Hospital at L'Gourline, France. His body was returned to his family, and he was buried at St. Francis Xavier Catholic Church at Newtown on January 8, 1919. On the back is written, "Our Hero. Died in France October 8th, 1918. Influenza cause of death. May he rest in peace. Amen. Age 26 years." (Courtesy Historic St. Mary's City Commission.)

LIST OF TROOPERS, 1814. During the War of 1812 members of the St. Mary's County Militia did not serve full time but were called to duty as needed. This list shows some of the men who were called to Clifton Factory during February 1814 and the number of days they served. It is an original and was handwritten by Lewis Medley. (Courtesy St. Clement's Island Museum.)

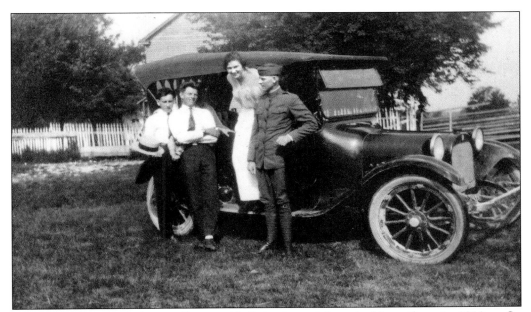

WILLIAM THOMPSON ABELL. Private Abell is pictured here in his uniform in 1919 at St. Inigoes soon after he came home. Also pictured, from left to right, are Abell's cousin Joe Dent; his brother Louis Abell; and his cousin Bessie Dent. He was inducted on August 15, 1918, and sent to France just one month later. While serving in the army, Private Abell was awarded the Serbian Order of St. Sava. (Courtesy Historic St. Mary's City Commission.)

LIBERTY BOND LETTER. This undated letter was written to Miss Emma Graves during World War I. The unnamed soldier may have been either her nephews, Benedict Booth Love Jr., or Philip Greenwell Love, both of whom served. During World War I, this was just one of the many fund-raising efforts to ensure that our soldiers would have sufficient food, clothing, and arms. Women even wore reversible dresses to conserve material. (Courtesy Betty Peterson.)

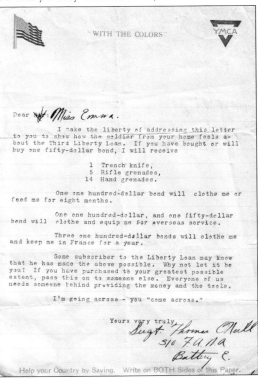

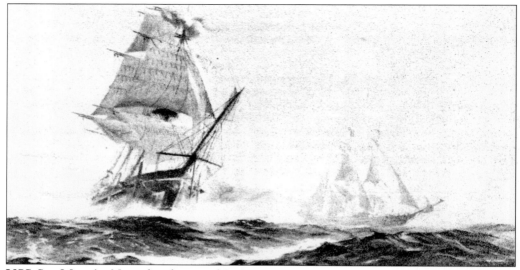

USS ST. MARY'S. Named in honor of St. Mary's County, *St. Mary's* was built in 1843. She served with distinction in the war with Mexico and afterwards to suppress the slave trade. In 1874 she became the first American nautical school ship at what is now known as the State University of New York Maritime College at Fort Schuyler, where the inner court formed by the fort walls is called St. Mary's Pentagon. (Courtesy Maritime College, State University of New York.)

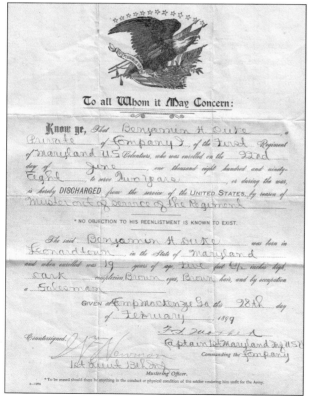

DISCHARGE LETTER. Benjamin Hooper Duke (1878–1946) served in the U.S. Army during the Spanish-American War. The back of this discharge paper says that he was "honest and faithful," and his character was described as "excellent." His brother, William Bernard Duke (1873–1946), also served. After the war, Benjamin Duke married Grace Aileen Dent, and they lived here until both died in the 1940s. (Courtesy Lois Duke.)

Eight
LAW AND ORDER

In addition to the court system established at the time Maryland was settled, disputes were decided and justice was sometimes meted out on the manor. Conditions of Plantation, published by Lord Baltimore in 1633, specified that for every five men transported to Maryland, 1,000 acres were to be granted to form a proprietary manor. Maryland was the only colony organized this way.

The lord of the manor, or his deputy (the steward), held a meeting of the manor court at least twice yearly. Tenants had to attend or be fined unless they could provide a valid reason for the absence. The court administered the agriculture of the manor and the lord's and tenant's rights and duties, and it resolved disputes between tenants. There were two types of manor courts with different functions.

The court leet dealt with the appointment of manorial officials; heard criminal offenses not punishable by common law, resolved disputes involving money over 40 shillings, and handled non-estate matters such as affray, selling merchandise, instruments of punishment, and general unsocial conduct.

The court baron dealt with changes in manorial tenancy, petty misdemeanors, money disputes involving less than 40 shillings, and minor infringements of property rights. It also legislated for the customs applying to the land, its use, and its family descent. The court leet and court baron generally met at the same time. It appears there were only two manors in Maryland stated to have had a court leet and court baron. One of these was St. Clement's and the other was St. Gabriel's.

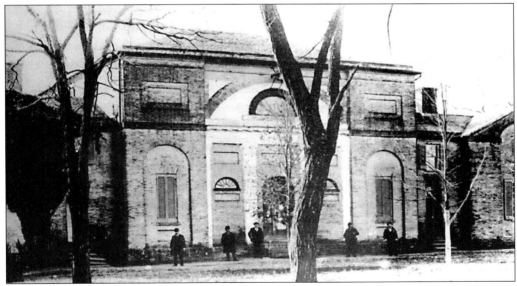

COURTHOUSE, 1832. This courthouse replaced the previous one that burned on March 8, 1831. The fire was catastrophic in that all of the early deeds, court records, and other records were lost. Only a handful of late 18th century and early 19th century marriage records survived. Mercifully, the state had required some records to be filed at the state level, such as wills and probate records. (Courtesy St. Mary's County Historical Society.)

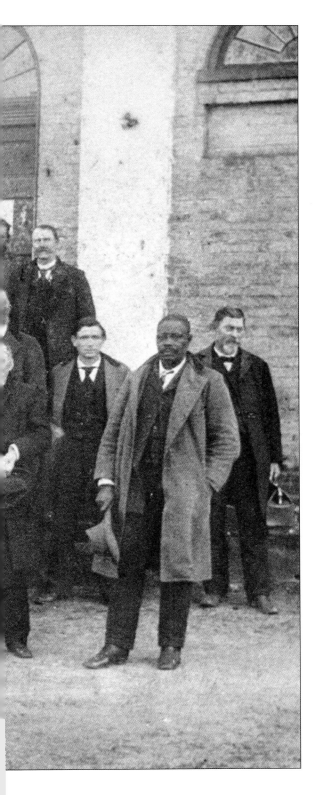

GRAND JURY, 1899. The grand jury convened twice yearly, in March and September. There was no noteworthy news at the time this one convened; however, there are men shown here for whom no other photograph exists, hence its importance. From left to right are (first row) Zachariah Graves, Bernard Long, Ben Love (sheriff), Henry Hall, Allen Tyler, J. Marshall Dent, Lonnie Cullison, two unidentified people, and William A. Lyon; (standing in front of Lyon) Daniel Hammett and James Sewell; (second row) Mr. Carter, Charles V. Hayden, John Abell, Jim Stone, and Josiah H.B. Hancock; (third row) two unidentified people, John W. Jones, and ? Buckler; (fourth row) ? Mattingly, Dick Edwards, unidentified, ? Tennison, and Alfred Sanner; (fifth row) two unidentified men. (Courtesy St. Mary's County Historical Society.)

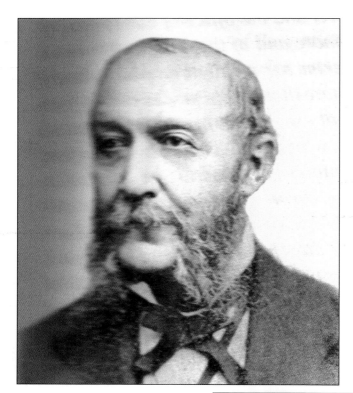

ROBERT FORD. Judge Ford was born in 1819. He was a lawyer and later served as an associate judge from 1867 until two years prior to his death in 1884. His father was John Francis Ford, who served as a lieutenant during the War of 1812, and his mother, born Priscilla Medley, served for a number of years as head of St. Mary's Female Seminary. (Courtesy Hon. Karen H. Abrams, St. Mary's County Circuit Court.)

JOSEPH HARRIS. Colonel Harris was born in Charles County in 1773 and came to St. Mary's County shortly after he married Susanna Reeder. They lived at Ellenborough, which Susanna had inherited from her unmarried brother, Thomas Reeder. Colonel Harris served as a clerk of the circuit court of St. Mary's County from 1795 to 1843. He also served in the 12th Regiment during the War of 1812. Colonel Harris died in 1855. (Courtesy Evelyn Arnold.)

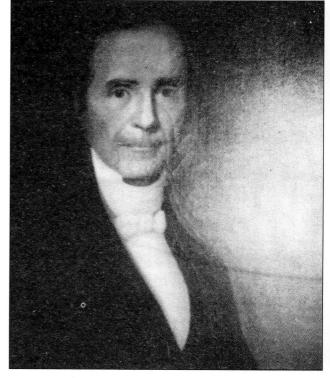

WILLIAM THEOBOLD MADDOX. Mr. Maddox was a clerk of the circuit court from 1843 to 1851. He was born in Charles County in 1790 but was here in time for the War of 1812, as he served as an ensign in the 12th Regiment under Capt. Enoch J. Millard. Maddox was elected sheriff in 1818, and in 1830 he was a member of the Levy Court. He died in Baltimore in 1870. (Courtesy Evelyn Arnold.)

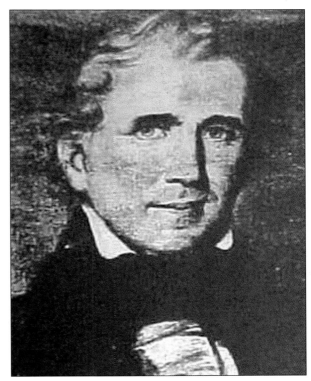

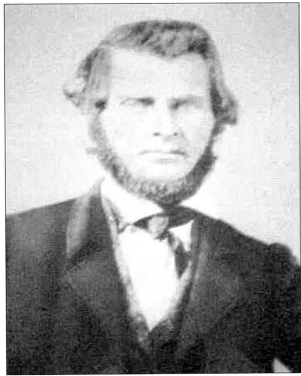

JAMES THOMAS BLACKISTONE. Colonel Blackistone was born in 1815. He was a lawyer and also served as a clerk of the court. According to family legend, Colonel Blackistone lost his home and possessions while playing cards at River Springs. There was a mirror hanging over the mantle, and it is said that the other man could see Colonel Blackistone's cards through its reflection. The mirror still hangs in the same place today. (Courtesy Evelyn Arnold.)

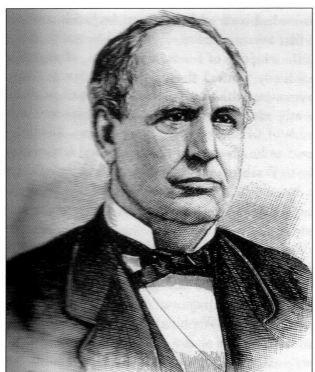

RICHARD HENRY ALVEY. Born in St. Mary's County in 1826, Richard Alvey was the son of George Alvey and Harriett Weaklin. Mr. Alvey had a long and distinguished law career. He wrote the *Alvey Resolution* outlining the states' rights view in 1861 and as a result was arrested by federal troops and held as a Southern sympathizer. (Courtesy Regional Publishing Company.)

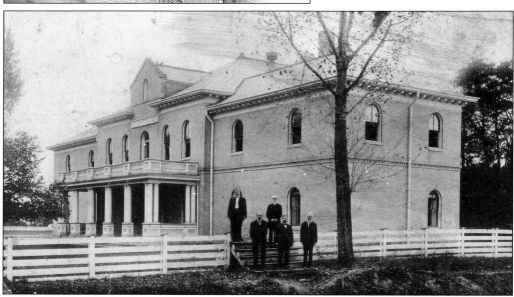

COURTHOUSE, 1910. Benjamin H. Camalier, circuit court judge (1909–1923), is standing on the top step. Prior to his appointment as judge, he was elected state's attorney in 1899, 1903, and 1907. Enoch Booth Abell, clerk of the court, is standing at the front in the center. He graduated from Georgetown University, was clerk of the circuit court from 1896 to 1922, and served as co-founder of the *Enterprise* newspaper in 1883. (Courtesy Historic St. Mary's City Commission.)

LUKE EDGAR BARBER. Born here in 1806, Barber was a lawyer. In 1836 he moved to Arkansas and just two years later was elected to the Arkansas legislature. In 1841 he was appointed clerk of the Supreme Court of Arkansas. He was also president of St. John's College in Little Rock. Mr. Barber died in 1886. His wife, Jane Pope Row Causine, was also a St. Mary's Countian. She died in 1897.

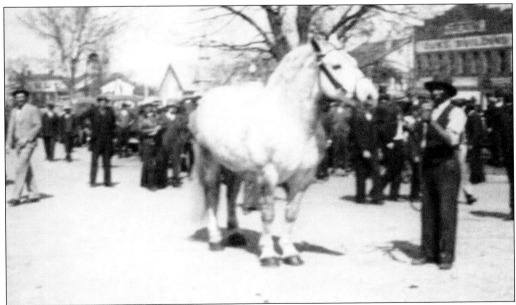

STUD HORSE TUESDAY, 1940. This tradition goes way back in time and was held twice each year, coinciding with the meeting of the grand jury. Farmers would bring their prize stallions to town and parade them around the square for possible "service" to mares in need. It was also a day to get together to discuss the cases under consideration, talk about the lawyers involved, and often to bet on the outcome. (Courtesy J. Harry Norris.)

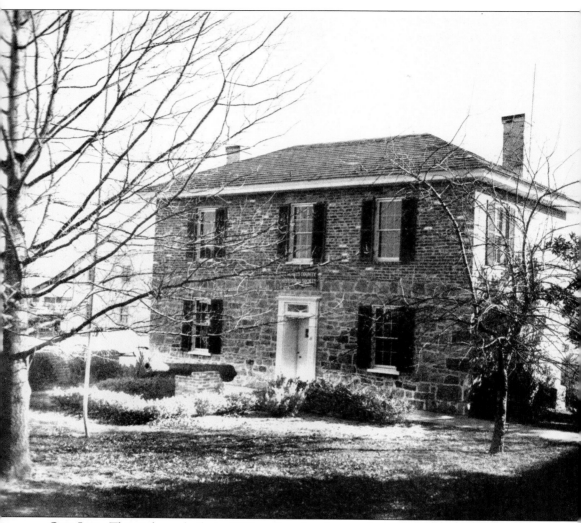

OLD JAIL. This jail was built in 1876 and replaced an earlier one built in 1858 when it was discovered that the mortar used was almost entirely sand. Prisoners quickly caught on that they could easily scratch away the mortar and escape. The grand jury repeatedly recommended building another jail. At one point they stated, "[W]e regard the jail in its present condition as a nuisance and public disgrace, and calculated to bring the administration of criminal law here into contempt." Finally in 1876 the jail of 1858 was torn down, and the building we know today was constructed. The jail was never designed to hold more than five or six prisoners, and with the onset of Prohibition, it was soon well over capacity. The prisoners reported in the morning and were required to stay in Leonardtown. Some spent the day playing cards in the basement of the St. Mary's Hotel, while others went fishing in Breton Bay. In the evening they checked out and went home. Many of the men said it was the best vacation they ever had! (Courtesy St. Mary's County Historical Society.)

Nine
FOOD, FUN, AND POTENT POTABLES

Churches are the nucleus for social activities in a rural area, and St. Mary's County is no exception. Practically every church has an annual church supper where the members put their best foot forward to cook delicious old-time food at an old-time price. The fare generally includes country ham or stuffed ham, fried oysters, and fried chicken as the main dish and a wide variety of vegetables, and, of course, there's always the bake-sale table loaded with delicious, homemade desserts. People sometimes travel hundreds of miles, and often more than once a year, for their favorite church suppers.

One very well-known cook was Pearl (Butler) Barnes, who donated her talents for church suppers in the seventh district. All you had to say was "Pearl" and "biscuits" and people knew exactly of whom you were speaking. Mrs. Barnes was renowned for her "beaten biscuits." This recipe was probably a holdover from slave days; it required that, before baking, the dough be beaten for a half hour using the dull side of the blade of a hatchet.

St. Mary's County also became famous for the quality of its homemade whiskey. Although the federal government was not too happy about it, especially during the days of Prohibition, it was sought after all over the United States and as far away as Canada. It is a long-time tradition that goes back hundreds of years, and as a host, you would have been considered rude if you did not offer your guests a nip or two.

GEESE. It would be highly unusual to enter the home of any waterman in St. Mary's County and not find a picture or carving of some of the beautiful geese that inhabit our shores. They are also hunted by avid sportsmen. This drawing by Carl Kopel celebrates this beautiful bird. (Drawing by and courtesy of Carl Kopel.)

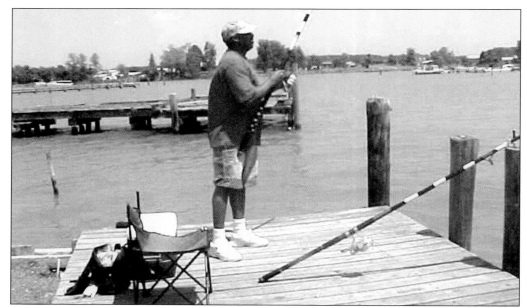

FISHING. Mike Evans, a resident of Baltimore, is shown here enjoying a leisurely day of fishing at White's Neck. Whether for work or play, fishing is an important part of life here. While some may find it unusual, local residents often eat fish at breakfast. For those who enjoy larger catches, there are always headboats at Ridge for outings into the Chesapeake Bay.

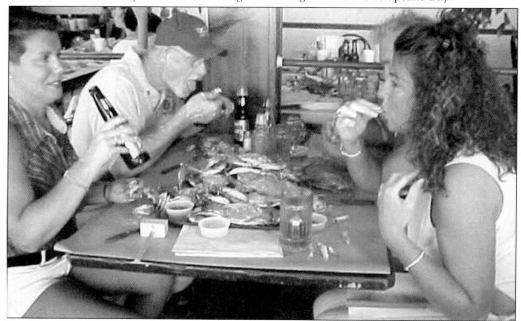

CRAB FEAST. The crabs caught in the waters surrounding St. Mary's County are the finest in the world. When taken from the water, they are beautiful shades of blue, hence the name blue crabs. When steamed, they turn red. When folks gather to eat crabs, it becomes a time to socialize—there is plenty of time for talking while getting into every nook and cranny for the succulent meat. Please don't forget the Old Bay!

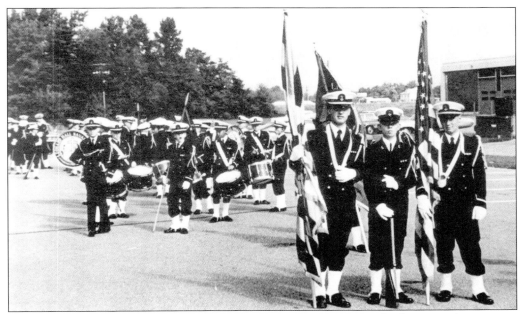

PARADES. Parades are generally held on Veteran's Day, Fair Day, and other special occasions. The Leonard Hall Junior Academy cadets are shown here getting organized. This excellent school, opened in 1909, is run by the Xaverian Brothers. The marching band is nationally recognized for its excellence and has participated in many Presidential inaugural parades. (Courtesy St. Mary's County Fair Board.)

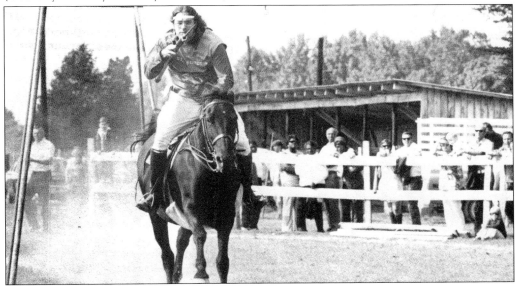

JOUSTING TOURNAMENT. Maryland achieved another first in 1962 when jousting became the first official sport adopted by any state in the country, based on legislation introduced by Henry Fowler of Horse Range in New Market. Mr. Fowler was also the founder of the Maryland Jousting Tournament Association. Jousting tournaments have been held here since Colonial times, most often at churches where the tournament was followed by a supper and then a dance. (Courtesy St. Mary's County Fair Board.)

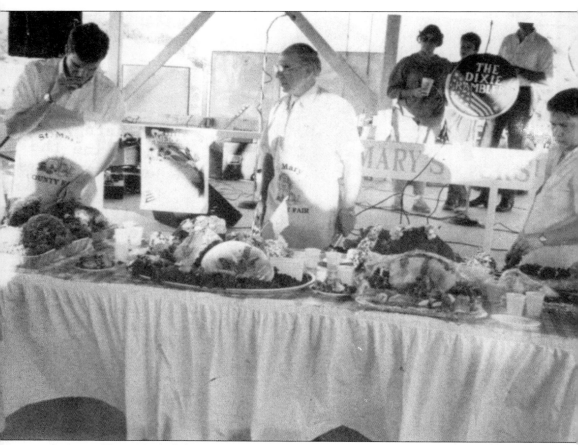

STUFFED HAM. No holiday or special event in St. Mary's County would be complete without stuffed ham. It is served on a daily basis in restaurants and the local grocery stores by the pound. It is considered a delicacy, and a write-up was recently done about it in *Gourmet Magazine*. Slits are made in a corned ham and filled with a stuffing made from cabbage, kale, onions, red pepper, black pepper, and mustard seed. Once this process is complete, the ham is wrapped in cheesecloth, secured with string, and boiled (not baked) until it is done. It is best served cold. Although stuffed hams are no longer judged at the county fair as shown in this picture, sandwiches are still sold at the concession stand. (Courtesy St. Mary's County Fair Board.)

BEACH BABY. St. Mary's County is on a peninsula and has over 400 miles of shoreline, so there is no lack of beaches should one desire to go swimming or enjoy any other of a multitude of water sports. Pack up the family, take along a picnic lunch, and enjoy a day that costs little or nothing but will leave you with a lifetime of pleasant memories.

SHUCKING CONTEST. Contestants from all over the country come to the Oyster Festival to participate in the United States National Oyster Shucking Contest. The winner receives an all-expense paid trip to Ireland, where he or she represents America in the International Oyster Shucking Contest. Contestants are judged on both speed and presentation. Since 1980 Wayne Copsey, a local resident, has won the men's division five times and was the national champion three times. (Courtesy St. Mary's County Fair Board.)

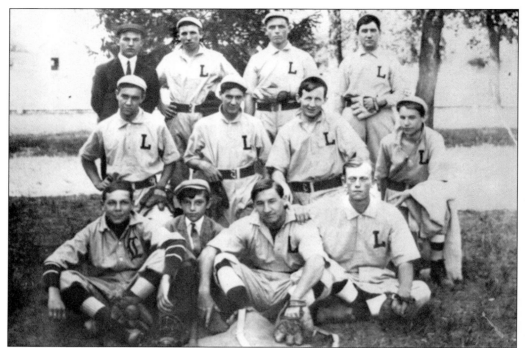

LEONARDTOWN BALL TEAM, 1911. Baseball and softball have always been a big part of the social scene in St. Mary's County. Teams are sponsored by businesses and social and fraternal organizations. Kids start playing almost soon as they can walk, and there are "over-the-hill" leagues for ages 50 and up. According to Aleck Loker, there was an organized baseball team in Leonardtown as early as 1866 and perhaps before. (Courtesy St. Mary's County Historical Society.)

ST. MARY'S COUNTY FAIR. Fairs were held here in the early 1900s but with no regularity until 1947. Since that time, they have been held in September every year. This picture, taken in 1947, shows cattle being judged. Fathers Kelly and La Farge are credited for fostering the idea of a fair in 1911 to "encourage young men to take pride in agriculture and strive to improve farming practices." (Courtesy St. Mary's County Fair Board.)

HORSE SHOWS. Maryland has always had a love of horses. We might surmise that the bloodlines of the horses taken by the St. Mary's County settlers when they went to Kentucky flow in that state's thoroughbreds today. A horse show is held at the county fair each year where these beautiful animals are put through the paces and "strut their stuff." (Courtesy St. Mary's County Fair Board.)

CARNIVAL. In earlier times, traveling carnivals came to this area. Later the Leonardtown fire department acquired a merry-go-round from New Jersey complete with an antique engine, built in 1905, that only they knew how to repair. Initially the Ferris wheel was placed in the middle of the street in Leonardtown in front of St. Paul's Methodist Church. Today just about every volunteer fire department in the county has a carnival to raise funds. (Courtesy St. Mary's County Fair Board.)

TELLING TALL TALES. According to Pete Winninton, whenever men gathered, sometimes at bars like the one shown here, they would invariably tell tales, each trying to top the other. Told seriously, it was impolite to laugh, and afterwards the listeners would say, "Yep, that's true." Some examples include the following: "That gun shot so far that when I went hunting geese, I had to mix rock salt with the shot so the bird wouldn't spoil before it hit the ground"; "One time my pigs rolled in the mud and it dried on their backs so hard, they couldn't close their eyes. They died of insomnia while standing up"; "The barrel of my shotgun is so big, I clean it by greasing a possum and running him down it"; and "I took my shotgun to the blacksmith and had the end of the barrel reshaped into a 'V' so when the geese fly over, I can get the whole flock with one shot." (Courtesy Pete Wigginton and Doug Lister.)

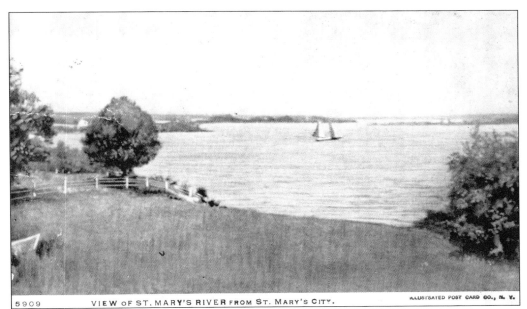

5909　VIEW OF ST. MARY'S RIVER FROM ST. MARY'S CITY.　ILLUSTRATED POST CARD CO., N. Y.

SAILING ON THE ST. MARY'S RIVER. This postcard shows a couple of sailboats many years ago on the St. Mary's River at St. Mary's City. Sailing enthusiasts from far and wide still come to St. Mary's to participate in regattas or simply to enjoy the sailing. Sailing is also one of the favorite pastimes for the students at St. Mary's College of Maryland, which has both a varsity sailing team and an offshore sailing team. (Courtesy Historic St. Mary's City Commission.)

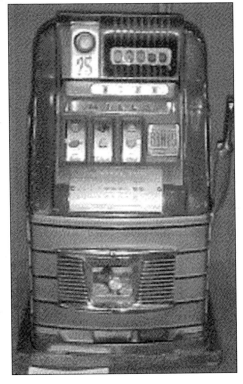

ONE ARMED BANDITS. In the 1940s, slot machines were legalized in several counties in Southern Maryland. They could be found in practically every restaurant, bar, gas station, and grocery store here. When the legislature outlawed them in 1968, Frank Abell, owner of a popular restaurant in the northern end of the county, had a slot machine "laid out" in a coffin.

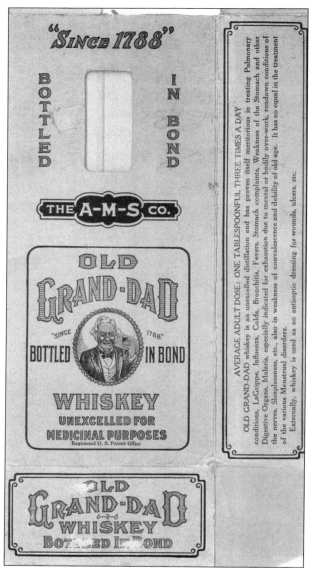

OLD GRAND-DAD. Basil Hayden was born in St. Mary's County on January 22, 1744. He was the great-grandson of Francis Hayden, a native of Watford, Herfordshire, England, who died in St. Mary's County in 1694. Prior to 1771 Basil Hayden married Henrietta Cole, who was born here on July 2, 1754. In 1785 Basil Hayden led one of the groups of Catholic settlers to Kentucky, settling at Pottinger Creek. There were a number of reasons people chose to move. Among them was the suffering that had been caused by the constant British raids during the Revolutionary War; the payment of Revolutionary War soldiers with land; large quantities of undeveloped western land made available cheap; and some still felt the sting of religious persecution that had existed since 1689. Undoubtedly, Basil soon began making the same whiskey his family had made for generations. He was known to be a Kentucky distiller as early as 1796. The picture on the label shown here is said to be reproduced from a crayon enlargement of a daguerreotype of Basil Hayden. (Courtesy Oscar Getz Museum of Whiskey History.)